mary Cassatt
Oils and Pastels

mary Cassatt
Oils and Pastels

By E. John Bullard

Published in Cooperation with the
National Gallery of Art, Washington, D.C.

Watson-Guptill Publications/New York

First published 1972 in New York by Watson-Guptill Publications,
a division of Billboard Publications, Inc.,
165 West 46 Street, New York, N.Y.

Manufactured in Japan

First Printing, 1972

Library of Congress Cataloging in Publication Data

Bullard, Edgar John, 1942—
 Mary Cassatt: oils and pastels.

 Bibliography: p
 1. Cassatt, Mary, 1844-1926.
ND237.C3B8 759.13 70-190524
ISBN 0-8230-0569-0

This book is partially the result of an exhibition of the work of Mary Cassatt which I organized at the National Gallery of Art in 1970, the largest retrospective of this artist yet held. The book was written at the suggestion of Donald Holden, Editorial Director of Watson-Guptill. To him and Diane Casella Hines, the Associate Editor who edited my manuscript and has seen the book through to press, go my sincerest gratitude and appreciation for their encouragement.

Many of the works reproduced in this book appear in color for the first time. My thanks to all the fortunate owners of these pictures who have so graciously allowed them to be illustrated. Nearly two-thirds of the color transparencies for this publication were produced by the National Gallery's Photographic Laboratory, under the able direction of Henry B. Beville. The superlative accuracy of the resulting reproductions is due to his great talent and that of his staff. My admiration and thanks go to them and to the other photographers who provided the rest of the excellent transparencies.

In writing this book, I have been especially fortunate to have had access to over two hundred and fifty letters from Mary Cassatt to Mrs. H. O. Havemeyer, the artist's oldest and closest friend. This unpublished correspondence, dating from 1900 to 1920, was deposited at the National Gallery by the Havemeyer family in 1963 and has since been classified and transcribed by David M. Robb, Jr. I am greatly indebted to the Havemeyer family, particularly Mrs. Havemeyer's heirs, for permission to quote from these letters. This correspondence has, I believe, yielded new insights into Cassatt's later years and made possible several important revisions in her chronology.

Anyone writing about Mary Cassatt is indebted to the authoritative research of two scholars. Frederick A. Sweet, retired Curator of American Art at The Art Institute of Chicago, is the author of the definitive biography of the artist published in 1966. Mr. Sweet has generously allowed me to quote from several of the letters and contemporary critical reviews found in his book. The leading authority on Cassatt is undoubtedly Adelyn Dohme Breeskin, retired Director of the Baltimore Museum of Art and present Curator of Contemporary Art at the National Collection of Fine Arts. Her two monumental *catalogue raisonnées* of Cassatt's work have been constant and reliable sources for my own research. I had the good fortune to work with Mrs. Breeskin on the National Gallery's Cassatt retrospective for which she wrote the catalog. Her enthusiasm, great knowledge, and unfailing connoisseurship impressed upon me the greatness of Mary Cassatt. I only hope that this book approaches Adelyn Breeskin's own high standards and accomplishments.

For my parents

SELECTED BIBLIOGRAPHY

Biddle, George. "Some Memories of Mary Cassatt," *The Arts*, X (August 1926), pp. 107-111.

Breeskin, Adelyn Dohme. *The Graphic Work of Mary Cassatt, a Catalogue Raisonné.* New York, 1948.

Breeskin, Adelyn Dohme. *Mary Cassatt: A Catalogue Raisonné of the Oils, Pastels, Watercolors, and Drawings.* Washington, D.C. 1970.

Burr, Anna Robeson. *The Portrait of a Banker: James Stillman, 1850-1918.* New York, 1927.

Carson, Julia M. H. *Mary Cassatt.* New York, 1966.

Cassatt, Mary. Correspondence addressed to Mrs. H. O. Havemeyer, 1900 to 1920. Typescripts of original letters on deposit at the National Gallery of Art, Washington, D.C.

Degas, Edgar. *Letters.* Edited by Marcel Guerin, translated by Marguerite Kay. Oxford, 1948.

Graphic Art of Mary Cassatt. Exhibition catalog, introduction by Adelyn D. Breeskin. The Museum of Graphic Art, New York, 1967.

Havemeyer, Louisine W. "The Cassatt Exhibition," *The Pennsylvania Museum Bulletin*, XXII, 113 (May 1927), pp. 373-382.

Havemeyer, Louisine W. *Sixteen to Sixty, Memoirs of a Collector.* New York, 1961.

Huysmans, J. K. *L'Art Moderne.* Paris, 1883.

Kysela, S.J., John D. "Mary Cassatt's Mystery Mural and the World's Fair of 1893," *The Art Quarterly*, XXIX, 2 (1966), pp. 129-155.

Mary Cassatt 1844-1926. Exhibition catalog, introduction by Adelyn D. Breeskin. National Gallery of Art, Washington, D.C., 1970.

Pissarro, Camille. *Letters to His Son Lucien.* Edited by John Rewald. New York, 1943.

Rewald, John. *The History of Impressionism.* Revised and enlarged edition. New York, 1961.

Sargent, Whistler and Mary Cassatt. Exhibition catalog, introduction by Frederick A. Sweet. The Art Institute of Chicago, 1954.

Ségard, Achille. *Mary Cassatt: Un Peintre des Enfants et des Mères.* Paris, 1913.

Sweet, Frederick A. *Miss Mary Cassatt: Impressionist from Pennsylvania.* Norman, Oklahoma, 1966.

Venturi, Lionello. *Les Archives de l'Impressionnisme.* Volume 2. Paris and New York, 1939.

Watson, Forbes. *Mary Cassatt.* New York, 1932.

1844. Born Mary Stevenson Cassatt, May 22 in Allegheny City, Pennsylvania, near Pittsburgh, fourth surviving child of Mr. and Mrs. Robert Simpson Cassatt.

1846. In January brother George born but died one month later. Father mayor of Allegheny City.

1849. In January brother Gardner born. In spring family moved to Philadelphia.

1851. In late summer family moved to Europe, settling in Paris.

1853. Family moved to Heidelberg, Germany, and later Darmstadt, so that the eldest son, Alexander, could study technical engineering.

1855. In May brother Robert died in Darmstadt. Late in year family returned to America, stopping in Paris to see the *Exposition Universelle*.

1858. After over two years in West Chester, Pennsylvania, family moved back to Philadelphia.

1861. In the fall enrolled at the Pennsylvania Academy of the Fine Arts, Philadelphia, attending classes for four years.

1866. In summer to Paris to study art, enrolling briefly in the atelier of the academic painter Charles Chaplin. For next four years pursued independent study in the museums, copying the old masters. Also made sketching trips in the country.

1867. Paris World's Fair with private exhibition pavilions of Courbet and Manet.

1868. Brother Alexander married Lois Buchanan, niece of the American President.

1870. Returned to Philadelphia after declaration of Franco-Prussian War on July 18.

1871. Late in year returned to Europe, settling in Parma, Italy, for eight-month study of Correggio and Parmigianino. Also studied engraving at Parma Academy.

1872. In May exhibited first painting at the Paris Salon, under name Mary Stevenson.

1873. Traveled in Spain and studied the collection in the Prado. To Belgium to see work of Rubens, and Holland to copy Frans Hals. Settled permanently in Paris. In May second picture exhibited at Salon. Met Louisine Waldron Elder, later Mrs. H.O. Havemeyer, and convinced her to buy a Degas pastel, the first Impressionist painting to come to America.

1874. In April exhibition of the *Société anonyme des artistes peintres, sculpteurs, graveurs, etc.* caused critical furor; group being dubbed the Impressionists. In May exhibited third painting in the Salon, where it was favorably noticed by Degas. Sent first two Salon pictures of Spanish subjects to the National Academy of Design's annual exhibition in New York.

1875. Sent two pictures to the Salon, one rejected.

1876. In April second Impressionist exhibition held at Galerie Durand-Ruel. In May had two pictures, including rejected one, which she toned down, accepted by Salon.

1877. In April third Impressionist exhibition in Paris. Introduced to Degas who asked her to join the Impressionist group. Sent last entry to Salon which was rejected. In fall parents and older sister came to Paris to live with her.

1878. Sent pictures to exhibitions in New York, Philadelphia, and Boston.

1879. In April participated in fourth Impressionist exhibition. In summer traveled in northern Italy with father. Sent two pictures to the second exhibition of the Society of American Artists, New York. Worked closely with Degas and Pissarro in planning journal, to be called *Le jour et la nuit*, featuring original prints.

1880. In April participated in fifth Impressionist exhibition. Extended visit of brother Alexander and his family. On her advice, he began to buy Impressionist pictures. Family began to regularly rent villas in countryside near Paris for summer months.

1881. In April participated in sixth Impressionist exhibition.

1882. Followed Degas and refused to participate in seventh Impressionist exhibition. Lent money to financially imperiled Durand-Ruel. In October brother Gardner married Eugenia Carter. Sister Lydia died November 7.

1883. In August Louisine Waldron Elder married Henry O. Havemeyer. Included in Durand-Ruel Impressionist show in London. In December went to Spain with mother, who was in poor health.

1884. In April family moved to new apartment at 14 rue Pierre Charron near Trocadero, with room for her studio.

1886. In May participated in eighth and last Impressionist exhibition. Durand-Ruel organized successful Impressionist show in New York, which included three of her pictures.

1887. In March family moved to apartment and studio at 10 rue Marignan, off Champs Elysées, which she kept for the rest of her life. In July brother Alexander and family arrived for fifteen-month visit.

1888. In summer broke leg in riding accident.

1890. In April visited great Japanese print exhibition at *Ecole des Beaux Arts* with Degas and friends. In summer and fall rented Château Bachivillers in Oise valley near Paris. Set up etching press there to produce set of ten color aquatints.

1891. In April first one-woman show at Galerie Durand-Ruel, Paris, at same time as exhibition of *Société des peintres-graveurs français*. Summer at Château Bachivillers. Father died in Paris, December 9.

1892. In summer, at Château Bachivillers, began work on mural for Woman's Building of 1893 Chicago World's Fair. Bought nearby Château de Beaufresne as permanent summer residence.

1893. In November/December large one-woman show at Durand-Ruel, Paris.

1895. In April large one-woman show at Durand-Ruel, New York. In fall brother Gardner and family arrived for two-year visit. Mother died at Château de Beaufresne, October 21.

1898. In fall visited America for first time since 1871. There executed portraits of children of friends and relatives.

1899. Return to Paris in March. Brother Alexander became president of Pennsylvania Railroad.

1901. In February extended trip through Italy and Spain with Mr. and Mrs. H. O. Havemeyer, advising them on purchase of paintings, particularly Goya and El Greco.

1903. One-woman show at Durand-Ruel, New York.

1904. Made Chevalier of the Legion of Honor.

1905. Executed paintings for the Women's Lounge in the new State Capitol, Harrisburg, Pennsylvania, but abandoned project after hearing of graft there.

1906. Brother Alexander died December 28.

1907. In March one-woman show at Galerie Vollard, Paris. In summer automobile tour of England, Scotland, and Low Countries with brother Gardner and family. Mr. Havemeyer died December 4.

1908. In fall made last visit to America, spending Christmas with Gardner and family in Philadelphia. In November one-woman show at Durand-Ruel, Paris.

1910. In December began extended trip with Gardner and family to Near East. Christmas in Constantinople.

1911. January and February in Egypt. Gardner seriously ill. Returned to Paris in March. Gardner died in Paris, April 5. Suffered nervous and physical breakdown, diabetes diagnosed. Gave up printmaking, stopped other work until 1912.

1912. In January to Cannes with James Stillman to recuperate. In June Achille Ségard began work on biography. In November rented Villa Angeletto, Grasse, near Cannes, where she wintered for many years.

1913. Did last works in pastel. Eyesight began to fail.

1914. In June one-woman show at Durand-Ruel, Paris. Outbreak of World War in August. Forced to close Château de Beaufresne which was in war zone. Lived in Paris and Grasse during most of war.

1915. In April featured with Degas in Suffrage Loan Exhibition, New York, organized by Mrs. Havemeyer. In October first operation for cataracts.

1917. Attended funeral of Degas who died in Paris, September 27. In December operation on cataract of right eye.

1918. James Stillman died March 15. End of World War in November.

1919. In October another cataract operation.

1920. Reopened Château de Beaufresne. Visits of relatives and friends resumed.

1921. In November final cataract operation unsuccessful. Nearly completely blind.

1923. Controversy over reprinting of old drypoint plates caused break with Mrs. Havemeyer.

1926. Mary Cassatt dies, Château de Beaufresne, June 14.

" I am not willing to admit that a woman can draw that well," exclaimed Edgar Degas after seeing one of Mary Cassatt's color aquatints. The year was 1891 and the two artists had already been close associates for over a decade. The artist herself said before her death, "After all, a woman's vocation in life is to bear children." These statements give some indication of the social and psychological restrictions which faced a woman who wished to be an artist during the second half of the nineteenth century. Mary Cassatt not only had to contend with the disapproval and indifference of her family, the condescending and patronizing attitudes of friends and associates, and the disregard of critics and collectors, she also struggled with her own ambivalent feelings about her role in society and her worth as an artist. Added to this, she was an expatriate, choosing to associate herself with the most avant-garde art movement of her time.

Mary Stevenson Cassatt was born May 22, 1844, in Allegheny City, Pennsylvania, now a dreary industrial suburb of Pittsburgh. She was the fourth surviving child, and second daughter, of Robert Simpson Cassatt and Katherine Kelso Johnston. The Cassatts were of French Huguenot stock, immigrating to America in the mid-1600's. Originally called Cossart, the name had evolved to Cassat around 1800; the family adopted the current spelling about the time of Mary's birth.

The Cassatt family was prosperous and well-connected; Robert Simpson Cassatt worked as a stockbroker and speculator in real estate. He served as mayor of Allegheny City in 1846 and president of the town's Select Council during the following two years. The family moved several times during this period, first to Pittsburgh, then to a country estate near Lancaster, and finally following the birth of the youngest son, Gardner, to Philadelphia in 1849.

Robert Cassatt, while mildly successful as a financier, was not conscientiously dedicated to business. Preferring a comfortable life of leisure to great wealth, he and his wife and five children embarked for Europe in 1851 and lived there for the next four years.

Possibly due to Mrs. Cassatt's French schooling in Pittsburgh and her fluency in the language, the family settled in Paris, taking an apartment there soon after Louis Napoleon had established the Second Empire. Since the oldest son, Alexander, displayed special technical aptitude, in 1853 the family moved to Heidelberg and then Darmstadt, Germany, where he studied at the *Technische Hoschschule*. There in May 1855, Robbie, the second son, died.

The Cassatts soon left Darmstadt for America, stopping en route in Paris to see the *Exposition Universelle*. The art section of this World's Fair featured large exhibitions of Ingres and Delacroix, the two antagonistic exponents of Neo-Classicism and Romanticism, while Gustave Courbet exhibited outside in his own unofficial *Pavillon du Realisme*. It is interesting to speculate on whether Mary Cassatt, then eleven years old, saw these exhibitions, particularly Courbet's, an artist she later admired. Such an experience could well have stimulated her own desire to become an artist. In any case, she returned home with a fluent knowledge of French and German and an introduction to the richness of the European artistic heritage.

On their return to Pennsylvania in late 1855, Robert Cassatt settled his family in West Chester, a country town outside Philadelphia where he owned property. A few years later, he paid $4,000 for a substantial, four-story brick house in Philadelphia, their residence until 1863. At that time they moved again to their country home in Chester County, where Mr. Cassatt took up farming. By then Alexander had graduated from Rensselaer Polytechnic Institute and begun his railroad career which would eventually lead to the vice presidency, and later, after a period of retirement, the presidency of the Pennsylvania Railroad.

Mary Cassatt began her artistic career in the fall of 1861 when she enrolled at the Pennsylvania Academy of the Fine Arts in Philadelphia. For four years she followed the stultifying academic course of study: first drawing from casts of antique sculpture, then drawing from the live model and studying anatomy, and finally making oil copies of third-rate academic paintings in the Academy's collection. If a student was talented and ambitious, the next step was to go abroad for further, similar study. During the 1850's American art students generally went to Germany, particularly Dusseldorf. After the American Civil War tastes changed and Munich and, especially, Paris were preferred.

Cassatt was frustrated and dissatisfied with her studies at the Pennsylvania Academy, where originality and freedom of expression were suppressed. Since America then possessed no public collections of great art, she decided that in order to be an artist she must go to Europe to study the old masters independently. For a man, such a decision to study abroad presented no problems, other than financial. Thomas Eakins, who studied at the Academy during the same years as Cassatt, went abroad in 1866 and enrolled at the *Ecole des Beaux Arts*. But for a young lady from the conservative, so-

cial background of Mary Cassatt, such an independent course was almost unthinkable. A young lady of good breeding might display an interest in the arts, such as playing the harp or painting on china, but she did not have any competitive, professional ambitions. The only acceptable role for a woman of this class in Victorian society was that of wife and mother.

Though determined to be independent, Cassatt was probably insecure and uncomfortable with such unconventional desires. As she wrote many years later (November 29, 1907?) to her closest friend, Louisine W. Havemeyer, "I think sometimes a girl's first duty is to be handsome and parents feel it when she isn't. I am sure my Father did, it wasn't my fault though . . ."

AFTER overcoming the considerable resistance of her father, Mary Cassatt departed for Paris in the summer of 1866; she was probably accompanied by her parents who saw to it that she was properly settled with friends of the family. Other friends and relatives visited her during these first years in Paris and she lived much the same *haute bourgeoisie* life she would have had in Philadelphia. The great difference was the art that she saw.

At first her parents insisted that she follow the prescribed academic pattern by continuing her studies in the studio of an established artist. Cassatt did study briefly in the atelier of the fashionable academic painter Charles Chaplin, but soon left for independent study in the great public art collections of Paris. Like many other foreign and French students, she copied works of the old masters at the Louvre. She also studied the work of contemporary artists in the Paris Salon and elsewhere.

Possessing an inquiring mind, Cassatt certainly must have seen the two exhibitions of Gustave Courbet and Edouard Manet held in their private pavilions outside the grounds of the Paris World's Fair of 1867. These two great exponents of Realism were completely opposed to the artificial conventions of the academic style espoused by the *Ecole des Beaux Arts* and the Salon. At this time, Manet, leader of the younger Realists, was particularly repudiated by the art establishment. He had acquired a notorious reputation after the exhibition of his *Le déjeuner sur l'herbe* at the Salon des Refusés in 1863 and his *Olympia* at the official Salon two years later. Both of these paintings—featuring nude women in contemporary settings—challenged and outraged hypocritical Victorian morality.

Manet was the most important influence on Cassatt in the years before 1875. From him and Courbet she gained an interest in the realistic portrayal of everyday life. This is not a surprising occurence for an American from Philadelphia, a city whose own early portrait tradition was so uncompromisingly realistic. Besides the 1867 Fair, Cassatt could also have seen Manet's paintings in the official Salon, where he continued to exhibit and was vilified regularly by critics. If she was particularly alert, she also may have noticed the early work of Edgar Degas who exhibited in the Salons between 1866 and 1870.

Cassatt continued her student life of looking, studying, and copying for four years. During the spring and summer, she went on extended sketching trips into the country with friends and produced her first pictures outdoors. The few paintings which survive from these years are very much the work of a student, undistinguished and devoid of any personal style. This period in her career came to an abrupt end with the outbreak of the Franco-Prussian War in July, 1870, when her parents insisted she return home to Philadelphia.

AFTER AN unproductive year and a half in Philadelphia, Mary Cassatt sailed to Italy in late 1871. She settled in Parma for eight months and seriously studied the work of the Mannerist painter, Parmigianino and, more important, his older contemporary, Correggio. For Cassatt, the memory of the latter artist's depictions of the Madonna and Child, executed in a soft, natural style, was a lasting one. At this time she also received an introduction to printmaking techniques, studying engraving at the local Academy with Carlo Raimondi.

In the spring of 1872, while in Rome, Cassatt took a step which she probably felt changed her status from an amateur to a professional. She submitted her first painting to the Paris Salon and was accepted. She must have felt a certain reluctance and modesty about this, however, for the picture was sent under the name "Mlle. Mary Stevenson." Her family's continuing disapproval and lack of understanding may have prompted her use of this pseudonym. As her brother Alexander rather nervously wrote to his fiancé, Lois Buchanan, niece of the American President, "[Mary] is in high spirits as her picture has been accepted for the annual exhibition in Paris. This you must understand is a great honor for a young artist and not only has it been accepted but it has been hung on the 'line'. . . . [Her] art name is 'Mary Stevenson' under which name I suppose she expects to become famous, poor child."

The painting, entitled *Before the Carnival* and inscribed *à Seville*, represented two women and a man in Spanish costume on a balcony, observing an unseen carnival below. This was the first of several depictions of Spanish characters by Cassatt and certainly indicated her knowledge of Manet's own paintings of similar subjects. Besides the portraits of flamenco dancers and toreadors which appeared in his 1867 exhibition, Manet had exhibited a painting, *Le balcon*, of the same subject, in the Salon of 1869. There it was severely criticized and even caricatured in the press. His painting was inspired in turn by *Las Majas al Balcón* by Goya, an artist he greatly admired.

It is not surprising then that early in 1873 Cassatt traveled from Italy to Spain visiting Seville and Madrid, where she de-

veloped her own enthusiasm for Goya and Velázquez. From Spain she sent her second acceptable entry, *Torero and Young Girl*, to the Salon; in terms of subject this painting was even closer to Manet. In the Prado she was also attracted to the work of Rubens and moved on to Belgium to pursue her studies of this Flemish master. At this time she also went to Haarlem where she copied the work of the Dutch portraitist Frans Hals. In fact, of the many copies Cassatt did during her years as a student, only one survives; a spontaneous and lively rendition of one of Hals' large group portraits.

In 1873 Mary Cassatt decided to settle in Paris. This decision proved crucial to her development as an artist, because for the rest of the century Paris was to be the center of all that was new and imaginative in painting. A number of younger artists, associates of Manet, were then organizing their first independent exhibition, thereby boycotting the repressive Salon which consistently rejected their innovative work. These artists demanded the right to exhibit freely, without submitting to a jury and the inequalities of the prize system.

Cassatt was naturally sympathetic to these aims and had already noticed and admired the work of several of these Frenchmen, particularly Edgar Degas. "How well I remember . . . seeing for the first time Degas' pastels in the window of a picture dealer on the Boulevard Haussmann. I used to go and flatten my nose against that window and absorb all I could of his art." At the same time (in 1873) as this discovery, she also met Louisine Waldron Elder, later Mrs. H. O. Havemeyer, who was attending a fashionable Paris boarding school. Cassatt quickly communicated her enthusiasm for Degas to her new friend and convinced her to purchase one of his pastels. This was the first Impressionist painting to come to America and the beginning of one of the country's finest art collections.

Degas was then actively involved in organizing the first exhibition of a newly formed group which called itself the *Société anonyme des artistes, peintres, sculpteurs, graveurs, etc.* The exhibition of 165 works by thirty artists opened in a rented photographer's studio on the Boulevard des Capucines on April 15, 1874, two weeks before the opening of the official Salon show. The one-month exhibition was only a success in its attendance. The bourgeois public came only to jeer, laugh, and condemn the artists, reflecting the almost universally harsh reviews of the Paris critics. The most devastating review appeared in the comic weekly *Charivari* in which Louis Leroy derisively labeled the group the Impressionists, after the title of a Claude Monet painting, *Impression, Sunrise*. Certainly Cassatt's reaction was entirely different, but she was one of the few perceptive visitors who realized that this exhibition represented a new and significant departure in painting.

While she was viewing the Boulevard des Capucines exhibition, Degas was also noticing her work. The Salon that year accepted—for the first time under her own name—Cassatt's realistic portrait of a plain but lively middle-aged woman; this painting owed much to her study of Courbet. When Degas saw the picture, he remarked to a friend, "That is genuine. There is someone who feels as I do." Although at this time they had mutual friends and already felt a sympathetic attraction to each others' work, Cassatt and Degas did not meet for another three years.

In the meantime she exhibited when possible and painted with increasing confidence. In 1874 Cassatt sent two of her Spanish pictures to the National Academy of Design in New York. The following year she submitted two pictures to the May Salon, but had one portrait rejected for being too brightly colored. The next year she had two accepted, including the rejected one which she had deliberately toned down. Disgusted by this repressive experience, her belief in the Independents' demand for "no jury, no prizes" was strengthened. In 1877 she submitted one more picture to the Salon, which was rejected, and never submitted again.

In April 1867, the Impressionists held their second group exhibition in Paris. Now reduced to eighteen participants, 252 works were exhibited in the gallery of the art dealer Paul Durand-Ruel, who had been buying the pictures of a number of these artists for several years. The exhibition met with the same public and critical response: almost total, uncomprehending outrage mixed with heavy sarcasm. The conservative and influential critic Albert Wolff complained that, "this accumulation of crudities . . . is shown to the public with no thought of the fatal consequences that may result! Yesterday a poor soul was arrested . . . who, after having seen the exhibition, was biting the passers-by."

Cassatt, of course, attended the exhibition and the influence of these paintings was by then evident in her own work. Her palette was lighter and more colorful; her subjects were primarily women seated indoors, reading books, sewing or playing with dogs. A particularly fine picture of this date—one of her few landscapes—is *Picking Flowers in a Field* (Plate 1). Inspired by similar works by Monet and Renoir, it shows that Cassatt also was painting *en plein air*, using the broken brushwork of the Impressionists.

1877 WAS an important year for Mary Cassatt. Following the third Impressionist exhibition in April held once again at Durand-Ruel, Degas came to her studio accompanied and introduced by a mutual friend, the painter Joseph Tourny. Knowing her admiration for the Independents and recognizing her talent and determination, Degas asked her to forsake the Salon and exhibit with them. As she told her first biographer, Achille Ségard, "I accepted with joy. Now I could work with absolute independence without considering the opinion of a jury. I had already recognized who were my true masters. I admired Manet, Courbet, and Degas. I took leave of conventional art. I began to live."

As a mentor Cassatt probably could not have selected a fi-

ner artist or a more difficult person. When they met Edgar Degas was forty-three, ten years her senior. They had a great deal in common. Degas came from a wealthy, upper-middle class family with important aristocratic connections; three of his aunts were duchesses. He had studied briefly at the *Ecole des Beaux Arts* and with academic artists, but like Cassatt most of his student years were spent studying and copying the old masters in France and Italy. A friend of Manet, Degas turned his back on the art establishment and joined the Independents. Degas preferred to depict the subjects he knew best, everyday scenes of the Paris bourgeoisie: the race course, the opera, the ballet, and his own family. By definition he was not a true Impressionist, a term he despised. He rarely depicted landscapes and never painted *en plein air*, but preferred to work in his studio from numerous preparatory drawings. Degas was a figure painter, concerned not with the effects of light but with the form and movement of the human body. His interests and approach were to become Cassatt's.

Degas and Cassatt were intelligent and opinionated, sharing similar tastes in literature, as well as in art. Both were independent; neither ever married, devoting their lives to their work. Degas was a great conversationalist and possessed a formidable wit which in later years became sarcastic and embittered. During many years of close association, Degas and Cassatt were often at odds and separated. As she later told Mr. Havemeyer, as quoted in her memoirs, "Oh, I am independent! I can live alone and I love to work. Sometimes it made him furious that he could not find a chink in my armour, and there would be months when we just could not see each other, and then something I painted would bring us together again and he would go to Durand-Ruel's and say something nice about me, or come to see me himself."

Naturally people have speculated as to whether or not Cassatt had an affair with Degas. Unfortunately their letters to each other have not survived, Cassatt burned his before her death. Considering their conservative social backgrounds and strong moral principles, such an affair was not likely. Neither ever approved of the bohemian life style enjoyed by some of their associates. In later life, Cassatt expressed strong objection to the adulterous affairs of certain social acquaintances. While this was surely their closest, perhaps only, emotional relationship, it was based on mutual respect and admiration.

While Cassatt was indebted to Degas for the inspiration and development of her mature style, he needed her appreciation and encouragement as well. On a more practical level, she was a factor in his financial success. In 1874 Degas' father died and left the family firm on the verge of bankruptcy. To save the family honor, the bank was liquidated and its debts were assumed by Degas, his sister, and his oldest brother. For the first time, he was dependent for his income on the sale of his pictures. Cassatt urged her wealthy friends and relatives to buy Degas' work and played an important role in promoting his reputation in America.

Soon after Cassatt and Degas met, her parents and older sister Lydia moved to Paris. By the following year, the artist was sharing with them a sixth floor walk-up apartment at 13 Avenue Trudaine on Montmartre; her studio was nearby. For nearly twenty years Cassatt was burdened with the care of her family. This not only interfered with her artistic production, it probably was another reason for her not having an affair with, or considering marriage to, Degas. He and her father did not get on. Cassatt was a dutiful and loving daughter and enjoyed the emotional security and companionship of her family. But their presence was a restricting responsibility.

After their meeting, the influence of Degas on Cassatt's work was more apparent. Most important, he introduced her to the new pictorial possibilities offered by Japanese prints and photography. The vogue for Japanese art among French artists, particularly the Independents, began in the late 1850's. Degas was especially attracted to the great simplicity of the woodblock prints which depicted scenes of everyday life. He collected and studied these works, eventually incorporating a number of their stylistic conventions into his own paintings. These conventions included the asymmetrical arrangement of a composition, often depicting a subject from an angle or viewed from above; the cutting of objects by the edge of the frame; the emphasis on a form's silhouette; and the use of contrasting areas of pattern.

At the same time, Degas also found similar pictorial effects in early instantaneous photographs. He collected photographs and used a camera himself at an early date. He was especially interested in the seemingly accidental cropping of a composition as in a "snapshot," the casual pose of a figure, and the distortion of perspective which made foreground objects appear disproportionately larger than those in the background. One of the first of Cassatt's pictures to use a number of these conventions was *Little Girl in a Blue Armchair* (Plate 2). Degas took a particular interest in the creation of this painting and even repainted part of its background at her request.

THE FOURTH Impressionist exhibition opened on April 10, 1879, and included Mary Cassatt among the sixteen participants. She was the only American ever to exhibit with this group and remained an uncompromising defender of the Independents' cause for the rest of her life. She showed two paintings, both of her sister. Her depiction of her sister in *Lydia in a Loge* (Plate 3) owed a great deal to Renoir in its bright coloring and vigorous brushwork. The subject, however, derived from Degas. Cassatt did several loge pictures which often included a mirror reflection behind the figure as a means of extending space; again this was a device used by Degas. Mirrors obviously fascinated Cassatt for she incorpo-

rated them into her compositions throughout her career (Plates 10,28,30).

Her work in the 1879 exhibition was noticed favorably by several critics, including Edmond Duranty and J. K. Huysmans, although she was generally considered a pupil of Degas. Her success seemed to have impressed her father, at last convincing him of her determination and ability. Exhibition attendance was large, although there were few sales. The profit from the admissions was equally distributed among the participants. With her share (439 francs) Cassatt bought pictures from the exhibition by Monet and Degas.

After a trip to Northern Italy with her father, Cassatt returned to Paris in the fall to begin her first serious work as a printmaker. Degas conceived the idea of publishing a journal—to be called *Le jour et la nuit*—which would feature original prints. He was joined in this venture by Cassatt, Pissarro, and several of their friends. While the publication never appeared, some important prints were produced (notably by Degas) and Cassatt's career as a graphic artist was launched. This project also deepened their friendship.

The prints for the journal were to have been aquatints. Degas, always interested in experimenting with new techniques, audaciously combined aquatint with etching, softground, and drypoint and produced two extraordinary prints for which Cassatt posed. Both prints show her in the Louvre: one depicts her in the Etruscan gallery; in the other, she is seen from the rear viewing paintings and leaning on her umbrella. For the next decade or so Cassatt frequently posed for Degas, particularly for his pictures of millinery shops to which she would accompany him to try on hats. She told Mrs. Havemeyer that she only posed "... when he finds a movement difficult, and the model cannot seem to get his idea." While Cassatt is not usually recognizable in these pictures, Degas did do a few portraits of her. The most important shows her seated, holding some playing cards. In later years, she found this picture so revealing and incisive that she instructed Durand-Ruel to sell it quietly, without revealing the identity of the sitter.

Inspired by her work for the journal, Cassatt continued to sharpen her graphic skill by executing numerous drypoints, a most exacting technique of drawing directly on the copper plate. As she rightly observed, "In drypoint, you are down to the bare bones, you can't cheat." Degas placed the greatest importance on draughtsmanship, always remembering Ingres' words to him as a student, "Draw lines, young man, many lines ... it is in that way that you will become a good artist." Certainly her self-imposed graphic discipline was important for Cassatt's painting, imparting a new strength to her forms and a sureness to her sense of composition.

Both Degas and Cassatt showed several of their journal prints in the fifth Impressionist exhibition, held during April 1880. Because of the time they devoted to the journal, neither of them had many new paintings to show. She again sent a loge picture, possibly the pastel of Lydia (Plate 4). Both the use of this medium and the spontaneous and lively handling of the chalks are a further indication of Degas' influence. He was particularly adept with pastel and used it increasingly after 1880. He combined it with oil or gouache, rubbed it, sprayed steam on the surface so that it could be worked with a brush, and layered color upon color to achieve rich effects.

Cassatt again received favorable mention in the press reviews of the 1880 exhibition. J. K. Huysmans, while still noting her dependence on Degas, wrote that, "Miss Cassatt has nevertheless a curiosity, a special attraction, for a flutter of feminine nerves passes through her painting which is more poised, more calm, more able than that of Mme. [Berthe] Morisot." Paul Gauguin, who also exhibited that year, compared her similarly to Morisot, the other important woman Impressionist, saying, "Miss Cassatt has as much charm, but she has more power." Cassatt was included in the sixth Impressionist exhibition the following year and showed studies of children, interiors, and gardens. In 1882, Degas refused to exhibit, since some of his friends were not acceptable to the group. Although Cassatt was asked to participate, she followed Degas' wishes and declined. Both were included in the eighth and last Impressionist group show, held in 1886.

Cassatt did not neglect exhibition opportunities in her own country. She had been represented at several of the annuals of the Pennsylvania Academy of the Fine Arts and the National Academy of Design in the late seventies. In 1879 she sent two pictures to the Second Exhibition of the Society of American Artists, a break-off group from the National Academy. She did not, however, receive the critical attention or approval in America which she was beginning to attain in France. This regrettable situation was to continue for most of her life.

IN SEPTEMBER of 1880 Mary Cassatt's brother, Alexander, and his family came to Paris for an extended visit. While he and his wife stayed in the city, their four children visited the artist and her parents at their summer villa in the country. Cassatt thoroughly enjoyed her nieces and nephews and, at this time, began the first of a long series of portraits of them. Their presence may have been the inspiration for her first important painting of a mother and child (Plate 8), the subject with which she is so popularly identified.

Some critics have considered Mary Cassatt's concentration on this theme a kind of maternal compensation. Consciously or unconsciously, she may have regretted not having had children of her own. This analysis, however, can be deceptive. She and Degas both intentionally limited themselves to certain familiar subjects. This allowed the full exploration and refinement of the compositional possibilities and variations of human movement. As Degas wrote to another artist, "... it is essential to do the same subject over again, ten times, a hundred times. Nothing in art must seem to be chance, not

even movement." While his range of interests were wider, encompassing more of the male pursuits of Victorian society, Cassatt limited herself to depicting an essentially domestic, feminine world.

While Cassatt was a conscientious artist, painting most of the day in her studio and working evenings on her prints, she did not produce an especially large body of work. In addition to over 225 prints, Adelyn Breeskin has cataloged 617 oils and pastels, executed between 1868 and 1914. However, many of these are student works or studies for important pictures. In contrast, Degas produced at least 1,466 oils and pastels, plus several hundred prints and numerous sculptures.

The principle cause for this small body of work was undoubtedly Cassatt's devotion to and care of her parents and sister. After a long illness, Lydia died in November 1882. In a letter to his son, Mr. Cassatt wrote, "Lydia says she [Mary] has developed into a most excellent nurse. As far as her art is concerned the summer has been lost to her." Mrs. Cassatt's health was also poor and during the winter of 1883/4, the artist accompanied her to Spain for several months in hope of an improvement. That spring, Cassatt had to search for a new apartment, because her mother could no longer climb the five flights of stairs. In 1887 the family moved again, this time to an apartment at 10 rue Marignan, near the Rond Point, which Cassatt kept for the rest of her life. There were interruptions caused by the visits of friends and relatives and the planning of the family's summer vacations in the country. Also, in the summer of 1888 Cassatt seriously injured herself in a riding accident. She broke her leg and dislocated her shoulder and was forced to give up riding completely.

The result of these distractions was that Cassatt produced only sixty-four known works in the years between 1881 and 1889. Several of these paintings are among her finest, including *Reading "Le Figaro"* and *Girl Arranging Her Hair* (Plates 10,12). During this decade, under the immediate impact of Degas' influence, Cassatt reached her artistic maturity. It is a shame that family responsibilities, which she may have left Philadelphia to escape, limited her from accomplishing more at that time.

Another reason for her limited production was Cassatt's financial independence. She did not need to support herself with the sale of her work. While neither she nor her parents were rich, they certainly enjoyed a life of comfort and leisure. Alexander Cassatt, wealthy from his years with the Pennsylvania Railroad, was generous and provided the family with funds for such luxuries as their own carriage. In comparison with most of the Impressionists, Cassatt was particularly well-off. The depression following the Franco-Prussian War, which caused the failure of the Degas family bank, lasted for six years. After a brief recovery, another financial crisis occurred in 1882. Paul Durand-Ruel, the Impressionists' loyal dealer, was imperiled due to the bankruptcy of an associate. Cassatt it seems quietly lent the

gallery enough money to survive the crisis. She also assisted her associates by buying their paintings and urging her friends and relatives to do likewise.

THE DECADE of the nineties was the most creative and productive for Mary Cassatt. In April and May of 1890 a great exhibition of Japanese art was held at the *Ecole des Beaux Arts* in Paris. With friends, including Degas, Cassatt visited the exhibition several times, especially to see the display of over 1000 wood-block prints and illustrated books. While she had known and been inspired by Japanese prints since the late 1870's, Cassatt was overwhelmed by this enormous exhibition. She bought a number of prints from the show, particularly figure compositions by Utamaro and Haranobu.

Cassatt soon began work on a series of ten color aquatints, attempting to capture the simplicity and refinement of the Japanese prints. These proved to be her most original and important graphic works and a unique contribution to the development of the medium. During the summer and fall of 1890, she rented the Château Bachivillers, about fifty miles north of Paris in the Oise valley. There she set up an etching press and hired a professional printer to assist her. The technique she developed in these works was extremely complex, involving the use of soft-ground etching, drypoint, and aquatint on three identical plates. Each copper plate carried different colors, which, when printed consecutively, registered together to create one composition. The Japanese influence is seen in her use of simple, unmodeled forms; bold outlines; rich patterns; and flattened perspective. In several of the aquatints, such as *The Letter* (illustrated p. 52), the models even appear to have oriental features. These Japanese elements are also found in her paintings of this period, such as *The Bath* (Plate 16).

After the last group show in 1886, a number of graphic artists who had exhibited with the Impressionists formed a new organization called the *Société des peintres-graveurs français*. Membership was limited to artists born in France; so Cassatt and Pissarro, who had been born in the West Indies, were excluded. The new group planned their first exhibition for April 1891 at the Galerie Durand-Ruel. In reaction to their exclusion, Cassatt and Pissarro decided to exhibit at the same time in two smaller, adjoining rooms at the same gallery.

Although limited to twenty-four graphics, notably the set of ten color aquatints recently completed, this was Mary Cassatt's first one-woman show. Always extremely self-critical and modest about her work, she now felt prepared for such an exhibition. Pissarro greatly admired her prints. Referring to the aquatints, he wrote his son Lucian, "the patriots . . . are going to be furious when they discover right next to their exhibition a show of rare and exquisite works. . . . I have seen attempts at color engraving which will appear in the exhibition of the patriots, but the work is ugly, heavy, lusterless and

commercial [in comparison]." While Cassatt's exhibition was praised by Degas and several of the critics, many of the male members of the *Société* were not pleased with the competition. Though proud of her growing fame, even her mother could not avoid expressing the male chauvinist view. During the summer she wrote her son, "Mary is at work again, intent on fame and money she says. . . . After all a woman who is not married is lucky if she has a decided love for work of any kind and the more absorbing the better."

In early 1892 Mrs. Potter Palmer, social grande dame, art collector, and chairwoman of the Board of Lady Managers of the 1893 Chicago World's Columbian Exposition, commissioned Mary Cassatt to execute a mural for the Woman's Building at the Fair. Designed by a woman architect and decorated by a number of prominent American women artists, the building was to exhibit the products of female skill and handicraft. Mary Fairchild MacMonnies, wife of the sculptor Frederick MacMonnies, was given the north tympanum to decorate, while Cassatt was given the south. Their respective subjects were "Primitive Woman" and "Modern Woman."

Cassatt again rented the Château Bachivillers and had a special, glass-roofed studio constructed in which to work. Rather than climb up and down on scaffolding, she had a trench dug beneath the mural, into which it could be lowered and raised. There she worked on the approximately fifty-foot wide composition through the summer, fall, and winter. Rather overwhelmed by the size (the largest easel picture she ever painted was only 52 x 36 inches), Cassatt divided the area into three panels, further reducing it by a wide, ornamental border. As she wrote to Mrs. Palmer in October, "My figures are rather under life size. . . . I could not manage women in modern dress eight or nine feet high." In the same letter the artist explained, "I have tried to express the modern woman in the fashions of our day . . . the sweetness of childhood, the charm of womanhood, if I have not conveyed some sense of that charm, in one word if I have not been absolutely feminine, then I have failed." The center panel showed *Young Women Plucking the Fruits of Knowledge and Science*, while at the sides she depicted *Young Girls Pursuing Fame* and *Music and Dance*. While the titles were allegorical, the actual compositions realistically portrayed women and girls outdoors: picking apples, playing instruments, running about, and tending their babies.

Working so far from Chicago caused delays and difficulties, due mainly to the inefficiency of Frank Millet, a muralist in charge of art finances at the Fair. At one point, exasperated by the red tape and unsure of her own work, Cassatt considered resigning. As she wrote to Mrs. Palmer in December, "I am no longer capable of judging what I have done. I have been half a dozen times on the point of asking Degas to come and see my work, but if he happens to be in the mood he would demolish me so completely that I could never pick myself up in time to finish for the exposition. Still he is the only man I know whose judgment would be a help to me."

Finally completed in early 1893, the mural was installed in time for the opening. Unfortunately, in the tympanum it was over forty feet above the floor, where it could not be seen properly. The mural is known only from contemporary photographs. After the Fair it disappeared and is presumed to be destroyed. In coloring and subject, it was probably close to the fine oil of 1893, *Baby Reaching for an Apple* (Plate 17).

In November 1893 Cassatt had her second one-woman show at Durand-Ruel's Paris gallery. This time she was well represented with ninety-eight works, including seventeen oils, fourteen pastels, and sixty-seven graphics. The exhibition was well received by both the French public and critics. In the catalog for the show, André Mellario ended his introduction by stating, "Cassatt is perhaps, along with Whistler, the only artist of eminent talent, personal and distinguished, that America actually possesses." More than the critics, Cassatt appreciated the esteem of her fellow artists. As Pissarro wrote his son, "At this moment Miss Cassatt has a very impressive show at Durand-Ruel's. She is really very able!"

Durand-Ruel had been exhibiting the Impressionists in New York with increasing success since 1885. In fact, American collectors were far in advance of the French in appreciating and purchasing the work of these artists. Cassatt finally had her first one-woman show in her own country at the New York branch of Galerie Durand-Ruel in April 1895. The exhibition did not receive nearly the critical attention or praise that her previous shows in Paris had merited. This lack of appreciation was a great disappointment to Cassatt, especially since she always considered herself an American artist.

From the sale of her works, Cassatt was able to buy the Château de Beaufresne at Mesnil-Théribus in the Oise Valley not far from Beauvais. This seventeenth-century manor house was to be her summer residence for the rest of her life. The large, three-story residence was surrounded by forty-five acres of grounds with gardens and a large pond behind. In 1893, after renovation, she spent her first summer there. Her father had died two years before, in the December following her first one-woman show. In October 1895, her mother, long an invalid, died at Beaufresne. The death of her parents at last gave Cassatt a free, independent life.

AFTER LIVING in France for over twenty-five years, Mary Cassatt visited America in the fall of 1898. This was her first trip home since 1871. Indicative of her lack of recognition in her own country, her arrival was briefly mentioned in one of the Philadelphia newspapers: "Mary Cassatt, sister of Mr. Cassatt, president of the Pennsylvania Railroad, returned from Europe yesterday. She has been studying painting in France and owns the smallest Pekingese dog in the world." Cassatt would probably have been most indignant about the reference to her dog, for she had long and lovingly kept Belgium griffons, not Pekingese.

In Philadelphia the artist stayed with her younger brother, Gardner, because she did not get along with Alexander's wife. There she did several pastel portraits of her nieces and nephews; the one of Gardner and Ellen Mary is particularly fine (Plate 22). Although she rarely accepted formal commissions preferring, like Degas, to depict only family and friends, Cassatt went to Boston to execute portraits of the children of Mr. and Mrs. Gardiner Green Hammond. She received this commission on the recommendation of John Singer Sargent, an artist she had known in Paris in the seventies but did not admire. While in New England, she also did portraits of various members of the Whittemore family in Naugatuck, Connecticut. By March 1899 Cassatt was back in France where she would live until her death, making one last visit to America in the fall of 1908.

The principle reason that Mary Cassatt left America to study in Europe was the lack of great public art collections in her own country. Although the situation had changed drastically since her departure, her trip to America in 1898 reminded her again of this great need. During the next decade Cassatt played a key role in building several important private collections which would eventually enrich American museums. The most important of these collections, and one of the greatest of the period, was that of Mr. and Mrs. H. O. Havemeyer. Cassatt had urged her young friend, Louisine Waldron Elder, to buy works of the Impressionists as early as 1873. After her marriage in 1883 to the sugar magnate Henry O. Havemeyer she and her husband began collecting on a much larger scale.

In January 1901, Mr. and Mrs. Havemeyer sailed to Italy where they joined Cassatt in Genoa for an important art-buying trip. Visiting museums and dealers in Italy, they traveled south to Sicily and back up to Venice. While in Florence, Cassatt engaged a full-time agent to ferret out important Renaissance paintings for the Havemeyer collection. After Italy, the three went on to Spain; in Madrid Cassatt found several great works by El Greco and Goya for them. Besides El Greco's *View of Toledo* and *Portrait of Cardinal Guevara*, which were bought after several years of negotiations, they purchased this artist's great *Assumption of the Virgin*. Since this enormous altarpiece was too large for their New York home— and The Metropolitan Museum of Art strangely refused to buy it—the Havemeyers sold the picture to Durand-Ruel. Determined that it should go to America, Cassatt was then instrumental in arranging for The Art Institute of Chicago to acquire this painting, the greatest El Greco outside of Spain.

Besides the work of the old masters, the Havemeyers also gathered together, again often on the advice of Mary Cassatt, possibly the finest private collection of nineteenth-century French art ever assembled. Besides forty-four works by Courbet, this part of the collection was especially rich in the work of the Impressionists. There were twenty-eight Monets, twenty-three Manets, and sixty-three oils, pastels, and draw-

ings, along with seventy-one sculptures, all by Edgar Degas. The Havemeyers also owned twenty pictures by Cassatt. Between 1900 and 1907, when Mr. Havemeyer died, the artist was especially active in advising her friends. They had complete confidence in her judgment and even placed discretionary funds at her disposal so that she could purchase immediately works which might otherwise be sold to another collector. As the artist had hoped, most of the Havemeyer pictures are now in various American museums. The bulk of the collection was given to The Metropolitan Museum of Art in 1929. As Louisine Havemeyer later wrote of Cassatt, "She was the most devoted friend, the wisest counselor, the most faithful ally anyone ever had. Without her aid, I should never have been able to make the collection...."

THOUGH the years between 1900 and 1910 were productive ones for Mary Cassatt, she did not pursue her career during that decade with the same energy and determination shown in the nineties. After her successful, one-woman shows, she felt that, at least in France, her work had received the recognition it merited. After 1900 there were no great bursts of creativity, such as had inspired the set of ten color aquatints or the Chicago mural. Even though she was free of family responsibilities, she did not increase her production appreciably. Now much of her time was taken up with the search for paintings for the Havemeyers and other collectors. Also by this date, Cassatt no longer maintained the close friendship with Degas, which had proven so crucial an inspiration. They held opposing opinions regarding the trial and imprisonment of Alfred Dreyfus, a scandal which rocked France in the late nineties. After the turn of the century, Degas became progressively reclusive and misanthropic due to the blindness which forced him to give up painting around 1908.

Cassatt's work during this decade was more frequently done in pastel than oil. Degas also preferred this medium as his eyesight dimmed, because it was not necessary to set up a palette or mix colors. In the late works of both artists, color was a much more important factor; it became brighter, at times almost strident. Both artists applied the chalk to the paper with vigor and with nervous, slashing strokes. Cassatt's interest in firm modeling and precise draughtsmanship gave way to softer, more impressionistic effects. Her subjects were less varied after 1900, restricted primarily to women and children or young girls (Plates 26, 27, 29).

Cassatt continued her loyal adherence to the Independents' cause during these years. Her work was sent regularly by Durand-Ruel to exhibitions in America where it was beginning to find a wider market. In 1904 one of her pictures was awarded a prize at the Annual Exhibition of the Pennsylvania Academy of the Fine Arts. In a letter to the Director of the Academy, she refused to accept the award, stating, "I ... who belong to the founders of the Independent Exhibition must stick to my principles, our principles, which were, no

jury, no medals, no awards. . . . Liberty is the first good in this world and to escape the tyranny of a jury is worth fighting for, surely no profession is so enslaved as ours." That same year she refused to serve as a juror for the Academy's Hundredth Anniversary Exhibition and also turned down another prize from The Art Institute of Chicago's Annual. Again Cassatt was ahead of her time. The Independents' movement in America did not begin until 1908 when Robert Henri and John Sloan, along with six of their friends, broke with the National Academy and held a group exhibition at the Macbeth Gallery, New York. This first effort eventually lead to the famous Armory Show of 1914 and the formation of the Society of Independent Artists in 1917.

While she believed in the Independents' cause, Cassatt had no appreciation or understanding of the later, radical work of several of her contemporaries or the revolutionary pictures of the Fauves and Cubists. For her, Degas was always the first and last great artist of her time. She could not comprehend Cézanne's growing reputation and influence which resulted in escalating prices for his works. She advised Mrs. Havemeyer to sell his work in 1912, for "the whole boom is madness and must fall." She was equally severe in her judgment of Monet's late work. Referring to his large paintings of waterlilies, she wrote to Mrs. Havemeyer (September 8, 1918), "I must say his pictures look to me like glorified wallpaper. . . . I won't go as far as D[egas] who thinks he has done nothing worth doing for twenty years, but it is certain that these decorations without composition are not to my taste." Cassatt completely rejected Matisse's work. In a letter to Louisine Havemeyer in March 1913 she exclaimed, "If you could see his early work! Such a commonplace vision, such weak execution, he was intelligent enough to see he could never achieve fame, so shut himself up for years and evolved this and has achieved notoriety. . . . It is not alone in politics that anarchy reigns, it saddens me, of course it is in a certain measure our set [the Independents] which has made this [freedom] possible."

In 1910, Mary Cassatt embarked on a trip to the Near East with her younger brother, Gardner, which was to have a disastrous effect on her health and her art. Since the death of her older brother, Alexander, in 1906, she had become increasingly devoted to Gardner, the last member of her immediate family. In the summer of 1907, the artist joined Gardner and his children on an extended automobile tour of England, Scotland, and the Low Countries. The following year, she made her final trip to America, spending Christmas with her brother in Philadelphia.

In December 1910, Mr. and Mrs. Gardner Cassatt and their two daughters met the artist in Paris and traveled by train to Constantinople. By January they were in Egypt, sailing up the Nile on a private *dahabeah*. This was Cassatt's first trip to the Near East and the artistic remains of ancient Egypt made a great impression on her. As she wrote Louisine Havemeyer

(March 7, 1911) after her return to Paris, "All that Egypt has left of me arrived this morning, what an experience. I fought against it but it conquered, it is surely the greatest Art the past has left us. All strength, no room in that first empire for grace, for charm, for children, none, only intellect and strength. . . . only if I can paint something of what I have learnt, but I doubt it." Regrettably Cassatt was not able to assimilate this experience, a new inspiration which might have invigorated her late work.

Gardner had become seriously ill with pleurisy during the Nile trip. Returning to Paris soon after his sister, he died on April 5, 1911. Already exhausted by the trip, the shock of her brother's death caused Cassatt a physical and nervous breakdown. Besides suffering from diabetes, Cassatt endured extreme neuralgic pains in her legs, making her an invalid for some time. She was forced by illness to stop all work for nearly two years, and, in fact, never resumed printmaking.

To recuperate, Cassatt went south to Cannes in January 1912, accompanied by James Stillman. Stillman, retired president and chairman of the National City Bank of New York, had lived in Paris for several years, where he met and became a close friend of the artist. Cassatt had actively advised him on the formation of his art collection which decorated his luxurious Paris mansion. After Degas, he was her closest male friend. While in Constantinople, she had written Stillman (December 22, 1910), "I often think of you with very affectionate regards and hope you will find that happiness you wish for. . . ." A few days later, she thanked him for his Christmas present, writing, "I don't suppose the scissors will cut our friendship, I would not like that, though you did laugh when I told you you had brought something into my life I had not had before." He may well have asked her to marry him. By 1910, Cassatt was in her mid-sixties, six years his senior, and she was no longer willing or able to give up her independence. After her breakdown, James Stillman was particularly considerate. It appears that he financed the first biography of the artist, begun by Achille Ségard in 1912, a project which revived her interest in working again. Stillman was also an avid collector of her paintings, acquiring twenty-three by the time of his death in 1918. Many of these were given anonymously by his son, Dr. Ernest Stillman, to The Metropolitan Museum of Art in 1922, which in turn distributed several to other museums across the country.

After the winter in Cannes with James Stillman, Cassatt decided to go south regularly during the cold months. In November 1912, she rented for the first time the Villa Angeletto in Grasse in the hills above Cannes. This was her winter home until 1924. Nearby was the aged and crippled Renoir whom she frequently visited. Perhaps inspired by Renoir's own determined effort to paint despite his physical infirmities, Cassatt began working again in late 1912. Using only pastel, she produced the last of her depictions of women and children, the theme which had occupied her attention for

over thirty years. While these efforts showed a decline in her powers as a draughtsman, her use of vivid color and her original sense of composition were responsible for some distinctive works (Plates 31, 32).

In July 1913, Mary Cassatt wrote to Louisine Havemeyer for the first time about the trouble with her eyesight that was developing. By 1915, cataracts had developed on both her eyes. The first operation for their removal occurred in October of that year, but proved to be only partially successful. Cataracts appeared again and, although she underwent several more operations in subsequent years, Cassatt's vision steadily dimmed; by the twenties she was nearly blind. Due to this affliction, she was forced to give up her work completely.

The deterioration of Mary Cassatt's vision coincided with the outbreak of the first World War in August 1914. Since Château de Beaufresne was in the war zone, at one time only fifty miles from the front, it was closed for most of the war. Another situation caused by the war was even more distressing for Cassatt. Mathilde Vallet, her devoted maid and housekeeper for many years, was deported as a German alien. The artist spent the duration of the war in her apartment in Paris or at the villa in Grasse, where she occasionally visited Mathilde across the border in Italy.

During the war years Cassatt was an ardent suffragette, as was Louisine Havemeyer. As the war dragged on, she became convinced that only women—by gaining the vote and taking an active role in government—could prevent another such world catastrophe. In 1915, Mrs. Havemeyer organized an exhibition in New York to benefit the suffragettes' cause, featuring the work of Cassatt and Degas. The artist lent her full support to this project, writing her friend (May 30, 1914), "You know how I feel about the, to me, question of the day, and if such an exhibition is to take place I wish it to be for the cause of Woman Suffrage."

BEFORE the end of the war, Edgar Degas died in Paris on September 27, 1917. Several years earlier, Cassatt had been responsible for bringing his niece, Jeanne Fèvre, from the south of France to Paris to nurse her blind uncle. Cassatt attended his funeral in Montmartre, writing to Mrs. Havemeyer (October 2, 1917), "Of course you have seen that Degas is no more. We buried him on Saturday, a beautiful sunshine, a little crowd of friends and admirers, all very quiet and peaceful in the midst of this dreadful upheaval of which he was barely conscious." She was immensely saddened by Degas' death, perhaps realizing that her last years would be marked by similar blindness, inactivity, and loneliness. As she wrote to the painter, George Biddle, "His death is a deliverance but I am sad. He was my oldest friend here and the last great artist of the nineteenth century. I see no one to replace him."

Mary Cassatt's last years were indeed lonely ones. While she continued to receive visits from friends and relatives from America, many of her oldest associates were dead. She was particularly embittered by the controversy over the reprinting in 1923 of some of her old drypoint plates. Brought to her attention by Mathilde, she thought that they had never been printed and was unable to see the poor quality of the resulting impressions. When the prints were questioned by Mrs. Havemeyer, who had the artist's best interests at heart, Cassatt felt challenged unjustly and broke off her oldest friendship.

The artist did entertain a number of young American painters and writers at her country home during her last years. They were devoted to her and enjoyed her reminiscences and her strongly worded opinions. Forbes Watson, who knew her at this time, later wrote, "The real point of meeting her, even then, was that one couldn't listen to her, pouring out her ardor and her understanding, without feeling his conviction in the importance of art to civilization intensified." Though she lived for over a decade without painting, Mary Cassatt retained her original enthusiasm and dedication to art until the end. She died at Château de Beaufresne on June 14, 1926, and was buried in the family vault at nearby Mesnil-Théribus.

Editor's Note: *In the excerpts from correspondence between Mary Cassatt and Mrs. H.O. Havemeyer, the original punctuation has been retained.*

COLOR PLATES

Plate 1
PICKING FLOWERS IN A FIELD
c. 1875
Oil on wood, 10½″ x 13½″ (26.6 x 34.3 cm.)
Collection Mrs. William Coxe Wright, St. Davids, Pennsylvania

While Mary Cassatt was primarily a figure rather than a land-scape painter, she often posed her models outdoors (see Plates 11, 17, 18). This small panel is the most beautiful of the few landscapes she painted. It indicates her early knowledge and appreciation of the Impressionists whose work she probably saw at the Galerie Durand-Ruel even before their first group exhibition in April 1874.

The use of bright color and broken brushwork, as well as the subject, was inspired by the landscape compositions of Monet, Renoir, and Sisley. In fact, Claude Monet probably showed a quite similar painting, entitled *Wild Poppies* (Musée du Louvre, Paris), in the 1874 exhibition. While Monet's picture also depicts a country field of wild flowers with a few figures, Cassatt has concentrated her attention on the small child in the foreground who gathers the poppies, iris, and Queen Anne's Lace. The summarily indicated forms and the vigorous brushwork convey the impression of a fresh and spontaneously observed scene; it most certainly was painted in the field, *en plein air*.

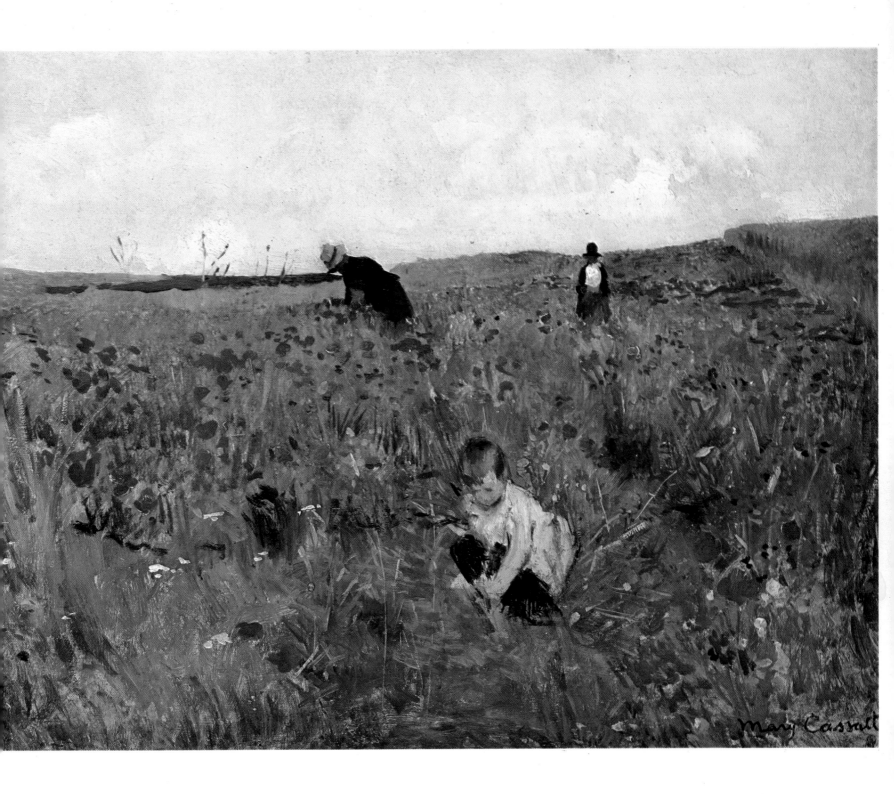

Plate 2
LITTLE GIRL IN A BLUE ARMCHAIR
1878
Oil on canvas, 35″ x 51″ (88.9 x 129.6 cm.)
Collection Mr. and Mrs. Paul Mellon, Upperville, Virginia

Soon after their meeting in 1877, Degas began advising Cassatt about her work. Regarding this painting, she later wrote the art dealer Ambroise Vollard, "It was the portrait of a child of a friend of Mr. Degas. I had done the child in the armchair and he found it good and advised me on the background and he even worked on it. I sent it to the American section of the big exposition [of 1878], they refused it. ... I was furious, all the more so since he had worked on it. At that time this appeared new and the jury consisted of three people of which one was a pharmacist!"

The portion on which Degas probably worked was the oddly shaped area of flat, gray floor. Around this area the four blue chairs circle like bump cars in an amusement park. The effect of light penetrating the cool room through curtained windows is also attributable to his brush. The entire picture shows Degas' influence, particularly in the asymmetrical composition, the extensive use of pattern, and the cropping of the painting on all four sides. This last stylistic device, especially, derived from Cassatt's study of the Japanese prints and contemporary photographs which Degas had brought to her attention.

The relaxed little girl in the armchair has been cleverly balanced by the amusing dog asleep in the chair at the left. This was one of Cassatt's Belgium griffons, a breed of dog she probably first discovered in Brussels in 1873 and kept all her life. These dogs appear in several of her other paintings (see Plates 9, 29).

In her best pictures, Cassatt presents a psychological analysis of her subjects, even if it is only the contented boredom of a comfortable, bourgeois life. In this painting the slightly languid and provocative pose of the little girl is disconcertingly similar to the young nymphetes in Balthus' post-World War II pictures.

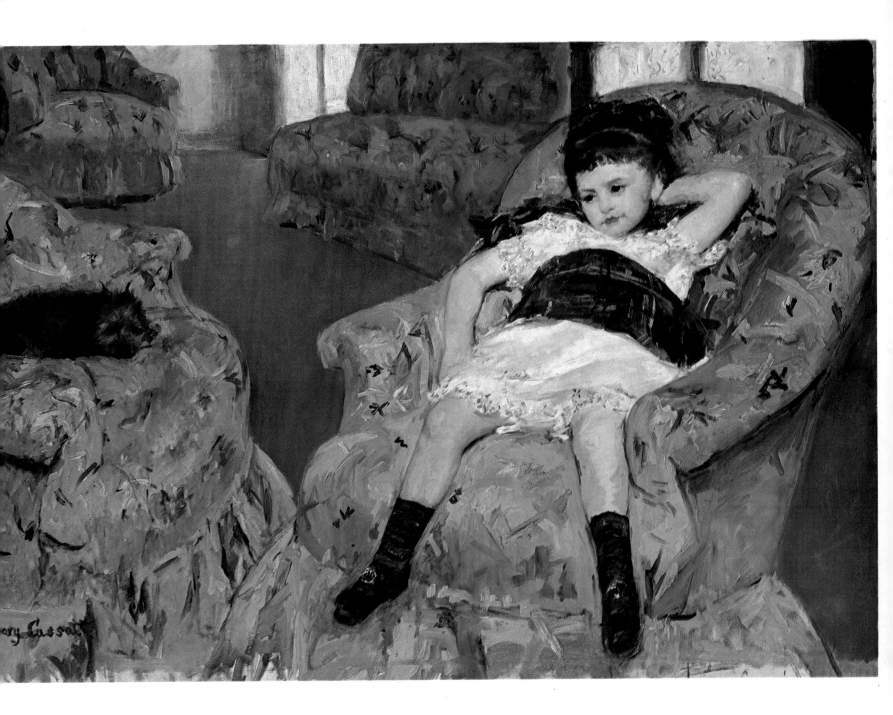

Plate 3
LYDIA IN A LOGE, WEARING A PEARL NECKLACE
1879
Oil on canvas, 31⅝" x 23" (80.2 x 58.3 cm.)
Collection Mrs. William Coxe Wright, St. Davids, Pennsylvania

In the late 1860's, Degas began his first depictions of the Paris ballet. While his early paintings were views of the stage from the audience, often including members of the orchestra or some spectators, he soon concentrated his attention on the dancers themselves. He particularly enjoyed the exaggerated perspective achieved when viewing the dancers from above, as they would be seen from one of the boxes. Around 1877 he first combined, in dramatic juxtaposition, the dancers on the stage with a portion of the box and its occupant, usually a woman with an open fan or opera glasses.

As seen in this painting, Cassatt adapted Degas' subject for her own purposes. Rather than showing the stage and its performers, she was interested in capturing the spectacle of the theater: the beautifully gowned women, the bright lights, and the vivid colors. This subject obviously fascinated her, because she painted at least eight variations on the theme, and created a number of similar prints. While mirrors were used frequently by Degas to extend the space in his compositions, the use of a mirror in a loge composition is uniquely Cassatt's invention. By posing her model in front of a mirror, she could then depict in the reflection the interior of the opera house with the audience seated in the loge tiers.

While the subject's inspiration came from Degas, the rich coloring—a harmony of reds and golds—is closer to the work of Renoir, who also did a few loge pictures. The vigorous handling of the paint and firm modeling of forms derived from Cassatt's study of Manet. This painting was included in the fourth Impressionist exhibition in April 1879, the first time Cassatt showed with the group. It was favorably noticed by several critics; it was even reproduced in one French publication *La Vie Moderne*. The woman depicted here is the artist's older sister, Lydia, who was her most frequent model until Lydia's death in 1882.

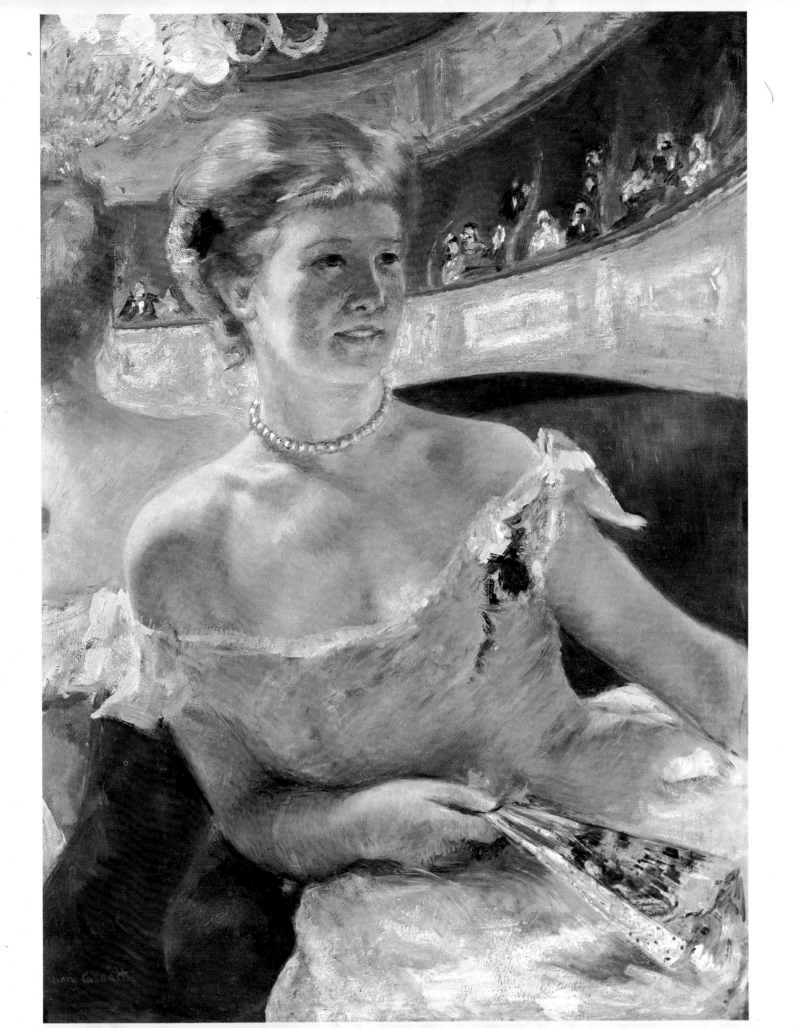

Plate 4
LYDIA LEANING ON HER ARMS, SEATED IN A LOGE
c. 1879
Pastel on paper, 21⅝″ x 17¾″ (55 x 45.1 cm.)
Private Collection

This pastel version of Lydia in a loge makes an interesting contrast to the oil painting of the same subject (see Plate 3). Rather than depicting her sister relaxing during an intermission, Cassatt has shown Lydia leaning forward to concentrate on the performance. This dramatic pose may derive from Degas' portrait of Mary Cassatt (collection André Meyer, New York), which shows her in a similar position with her hands clasped holding some cards.

The descriptive details of costume and audience found in the oil painting are replaced here by the shimmering effects of light playing over richly colored surfaces. The firmly modeled forms of the painting have been dissolved by the short, crosshatched strokes of pastel. In this version, a sense of excitement and spontaneity is conveyed by the handling of the chalk which is laid down in a nervous, agitated manner similar to Degas' technique. The luminosity and transparency in the flesh tones have been achieved by the layering of different colors, one on top of another.

This picture may well be the one included in the fifth Impressionist exhibition in 1880, where J. K. Huysmans favorably noticed, "the charming picture of a red-headed woman, dressed in yellow her back reflected in a mirror in the purple background of an opera box." The picture certainly conveys that quality of "the flesh tints of women fatigued by late nights and the shimmering light of fashionable gowns," which another critic noted earlier in both the work of Degas and Cassatt.

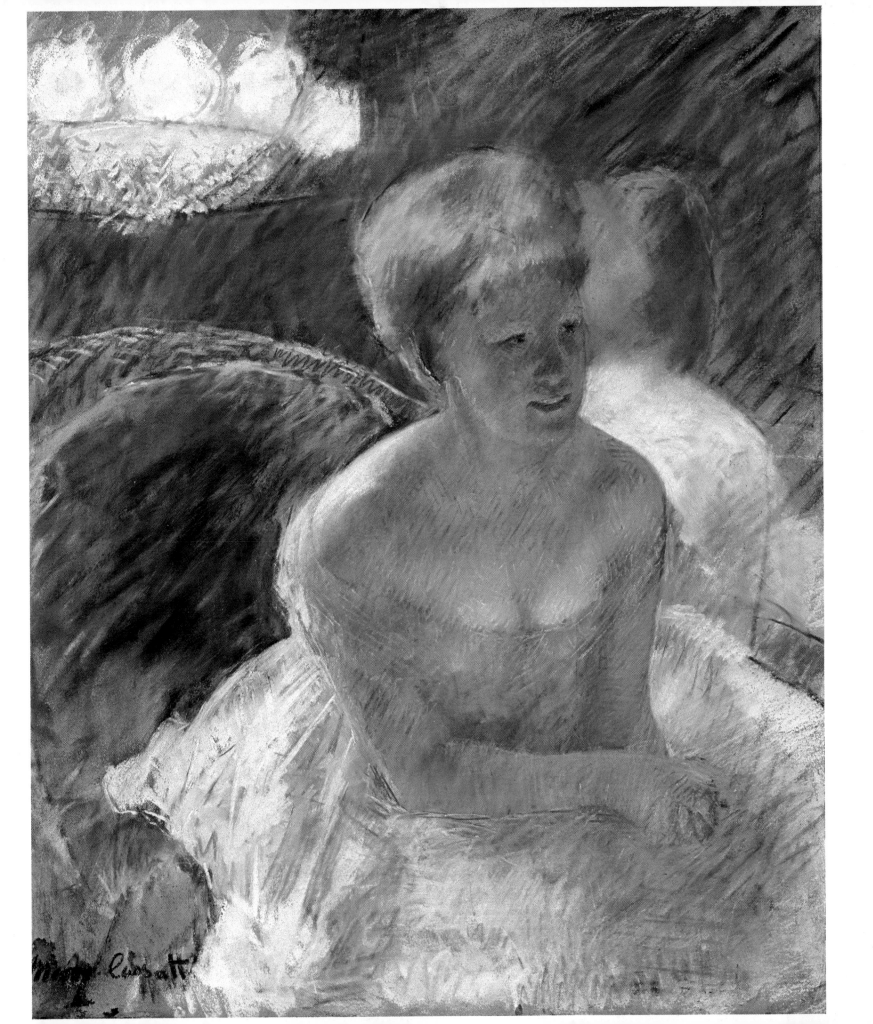

Plate 5
WOMAN AND CHILD DRIVING
1879
Oil on canvas, 35¼″ x 51½″ (89.6 x 130.8 cm.)
Philadelphia Museum of Art, Philadelphia, Pennsylvania
W.P. Wilstach Collection

In the spring of 1879 Alexander Cassatt established a trust fund for his parents which supplemented the fixed income on which they had lived since moving to Paris two years earlier. With this extra money, the family was able to purchase a pony and cart. This luxury was partly necessitated by Mrs. Cassatt's heart condition. Also Mary Cassatt was an avid horsewoman and was, as her mother wrote, "so fond of all sorts of animals that she cannot bear to part with one she loves." The artist rode regularly, whether in the city or country, until injuries from a riding accident in 1888 forced her to give up the sport.

In this large oil, Cassatt has depicted the new cart and pony, who was called Bichette, during a drive in the Bois de Boulogne, although only the hindquarters of the pony can be seen at the left. Lydia is driving and next to her sits Odile Fèvre, a niece of Degas, the youngest daughter of his sister Marguerite.

Again reflecting her interest in Japanese prints and photography, Cassatt has severely cropped the composition and achieved the intimacy of a snapshot. The asymmetrical arrangement of the picture is extreme with the three figures concentrated in the right half. The composition is tied together by the curves of the carriage and the harness and reins; this creates a linear pattern which crosses the picture from right to left and back to Lydia's hands. Unfortunately the stiffness of the figures creates a posed and static effect rather than a natural or spontaneous one. There is little feeling of movement or action. The distinctive profile of the young groom, silhouetted against the forest greenery, acts as an amusing foil to the serious expressions of the other two passengers. Although the scene occurs outdoors, the landscape remains anonymous and undefined—a mere backdrop against which the figures are posed.

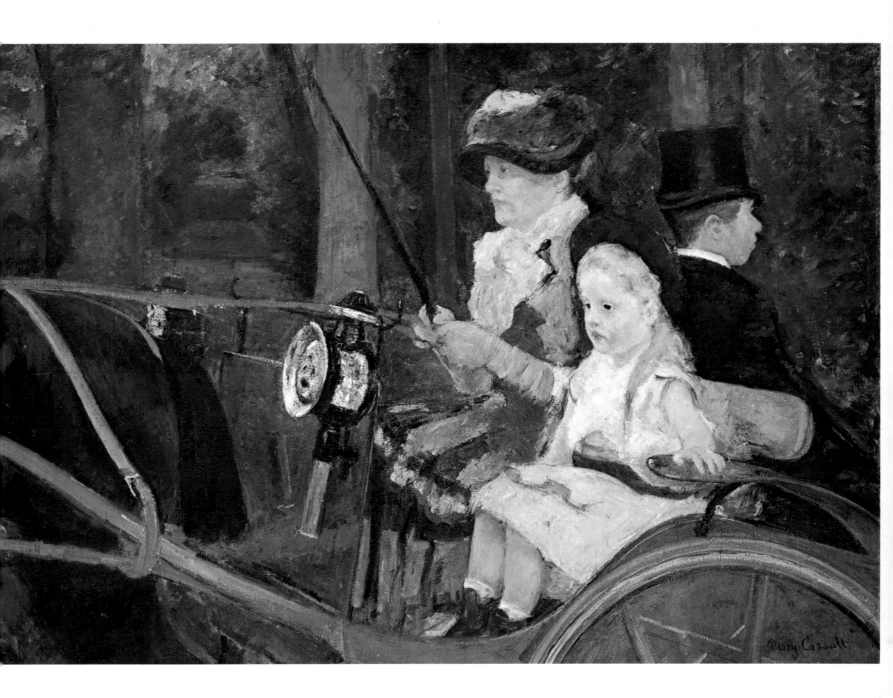

Plate 6
A WOMAN IN BLACK AT THE OPERA
1880
Oil on canvas, 32″ x 26″ (81.3 x 66 cm.)
Museum of Fine Arts, Boston, Massachusetts
Charles Henry Hayden Fund 1910

This is one of the few loge pictures by Mary Cassatt which does not incorporate a mirror reflection. Here the occupant of the box is seen from the side with the other loges in the background. Cassatt has attempted the extreme juxtaposition of scale and perspective found in Degas' loge compositions. In this case a humorous interplay had been created: the woman in the foreground, intently viewing the theater through her opera glasses, is in turn being scrutinized by the man in the background box. The. two figures are visually linked by the red velvet arm-rail, which curves through the composition.

Perhaps more than any of Cassatt's other mature works, this picture is indebted to Edouard Manet. A similar use of rich and varied blacks—the woman is in afternoon dress because she is attending a matinée—is found in many of Manet's pictures, particularly his depictions of Spanish subjects. On several occasions he painted women similarly dressed in black, including an 1872 portrait of Berthe Morisot. Also reminiscent of Manet is the summary manner in which Cassatt has indicated the figures in the background boxes. Only a few quick strokes of the brush are used—a dot of color, a dash of black. This bravura handling of paint can be seen in Manet's work also, such as the figures reflected in the mirror behind his *Bar at the Folies-Bergère* (Courtauld Institute, London).

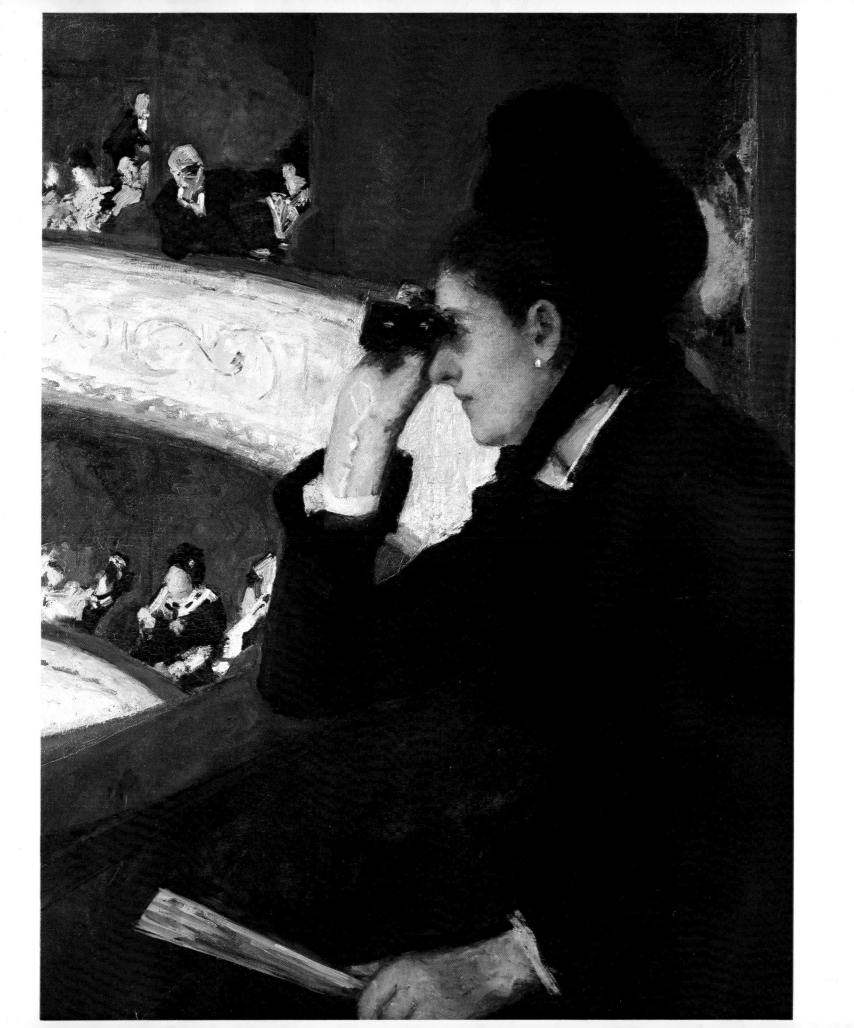

Plate 7
FIVE O'CLOCK TEA
1880
Oil on canvas, 25½″ x 36½″ (64.8 x 92.7 cm.)
Museum of Fine Arts, Boston, Massachusetts
Maria Hopkins Fund

While concentrating on landscape, a number of the Impressionists, such as Monet and Renoir, depicted the leisure pursuits and amusements of the middle class: cafés, the theater, dance halls, and picnics. As one contemporary critic observed, Cassatt was particularly attracted to this type of subject, but with a difference: "still the bourgeoisie ... it is a world also at ease but more harmonious, more elegant." This painting of afternoon tea epitomizes the the world of Mary Cassatt. It is proper, fashionable, comfortable, and, above all, quiet. She rarely depicted scenes of action or movement. A feeling of contemplation and quietude usually permeates her work. This quality is also found in her paintings of children, who are always well behaved—never running about, noisy, and active.

In this picture, included in the fifth and sixth Impressionist exhibitions, Lydia is seated at the left. Next to her, a woman is drinking tea. Her cup is frozen in midair, obscuring half her face in a most unorthodox manner. Again the composition's arrangement is asymmetrical; the two figures in the left half of the picture are balanced by the tea service and fireplace at the right. The center of interest is as much this tea service as the figures. While Cassatt rarely painted still life alone it often played an important role in her compositions (Plates 12, 16). Here the metallic qualities of the silver tea service, a family heirloom, have been beautifully rendered with its highlights and reflections. The simple, blue and white tea cup on the tray contrasts with the luxurious silver and also echoes the cup and saucer held by the woman on the sofa.

This painting is an excellent demonstration of Cassatt's use of pattern, an interest she shared with Degas. The regularly striped wallpaper creates a static backdrop for the curves of the figures and the sofa, which is covered in a flowered chintz favored by the artist. Cassatt's bravura brushwork is seen particularly in this chintz pattern and also in the rendering of the framed mirror and blue ginger jar above the mantle.

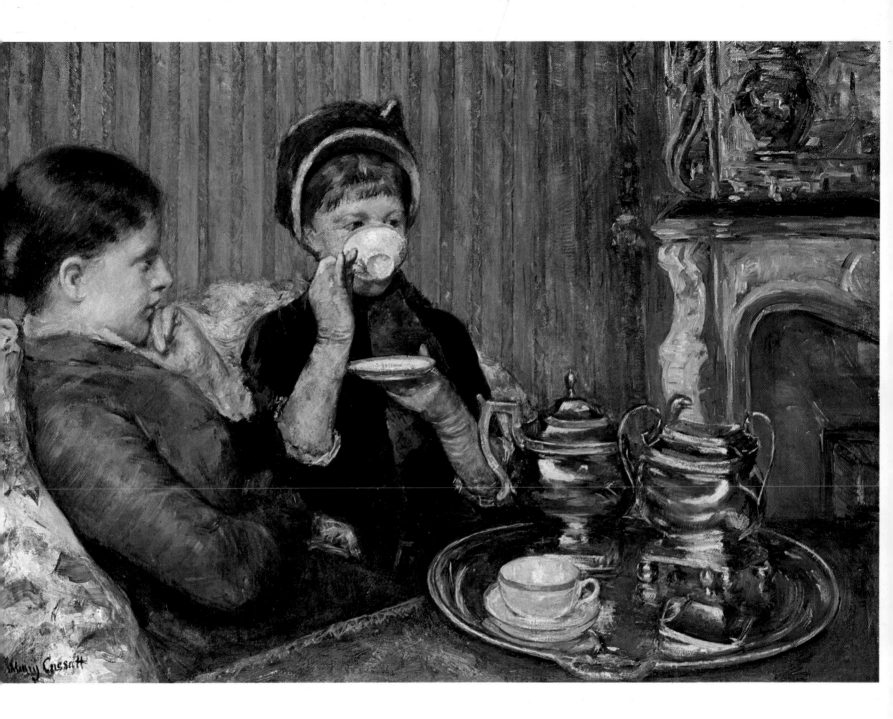

Plate 8
MOTHER ABOUT TO WASH HER SLEEPY CHILD
1880
Oil on canvas, 39½" x 25¾" (100.4 x 65.4 cm.)
Los Angeles County Museum of Art, Los Angeles, California
Bequest of Mrs. Fred Hathaway Bixby

In the fall of 1880, Alexander Cassatt and his family came to Paris for an extended vacation. While he and his wife remained in the city, their four children visited their grandparents and aunts in the country. Mary Cassatt particularly enjoyed their presence and took them on several excursions. During this visit she executed the first of many portraits of her various nieces and nephews. The arrival of these young children may have inspired this painting, considered the first of her many renditions of the mother and child theme.

While nearly a third of her production is devoted to this subject, Cassatt consistently brought an objectivity and originality to these pictures which saved her from the hackneyed and sentimental. During the eight months she spent in Parma in 1871-72, Cassatt carefully studied the work of Correggio and Parmigianino. Late in life she recalled the impact of these two artists on her development. The pose of the baby in this painting, with its spread and dangling legs, is reminiscent of several of Correggio's depictions of the Madonna and Child.

The extended vertical format of this picture was one frequently used by Mary Cassatt. Here the shape is emphasized by the stripes of the wallpaper and chair fabric. As in most of her mother and child compositions, the two figures form a compact and unified group; thus the structure expresses a close maternal relationship. The painterly quality of the brushwork, especially in the shimmering whites of the clothing and the wall covering, makes this one of Cassatt's most Impressionistic works. Later, the forms in her pictures become more solidly modeled and sharply defined.

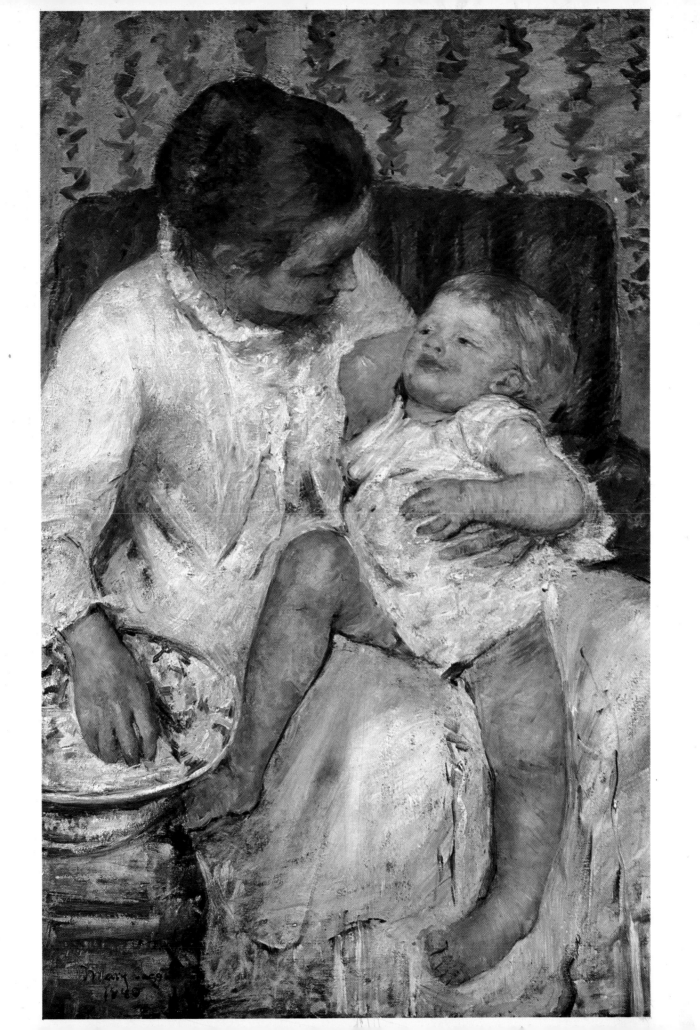

Plate 9
SUSAN ON A BALCONY HOLDING A DOG
1883
Oil on canvas, 39½" x 25½" (100.4 x 64.8 cm.)
The Corcoran Gallery of Art, Washington, D.C.

Lydia Cassatt died in November 1882, after suffering for many years from Bright's Disease. She had served as her sister's regular model since she moved to Paris with her parents in 1877. This painting was done soon after her death. The young model is probably a cousin of Mathilde Vallet, the artist's devoted housekeeper and maid. Not pretty, her strong features are reminiscent of Lydia's and are typical of the type of plain women Cassatt preferred as her models. She is seated on the balcony of the family's apartment at 13 Avenue Trudaine, with a view of Montmartre rooftops in the distance.

Cassatt frequently dressed her models in white, so that she could paint the subtle variations in tone caused by the changing light and surrounding colors. Here she has also captured the soft effect of daylight on the girl's face, as it is filtered through her hat. One of Cassatt's frequent compositional devices was to contrast the vertical elements in the picture with curvilinear ones. In this case the extended vertical format of the composition is reinforced by the doorjamb, the balcony railing, and the chimneys of the background buildings. These verticals act as a foil to the curves of the girl's hat and shoulders, the back of her chair, and the dog.

The dog is one of Cassatt's pet Belgium griffons, seen earler in *Little Girl in a Blue Armchair* (Plate 2). It is known that this particular dog was called Batty. Returning from a trip with the artist in 1883, her teenage nephew Eddie wrote, "We did not bring Batty along, thank fortune, as I would have had to carry him and the valise and the shawl strap and two umbrellas, to get tickets and find a compartment which would hold all those things." While they were nervous and tempermental animals, Cassatt was devoted to these dogs all her life. Around 1890, Degas even did a pastel portrait of Cassatt with a griffon similarly posed on her lap.

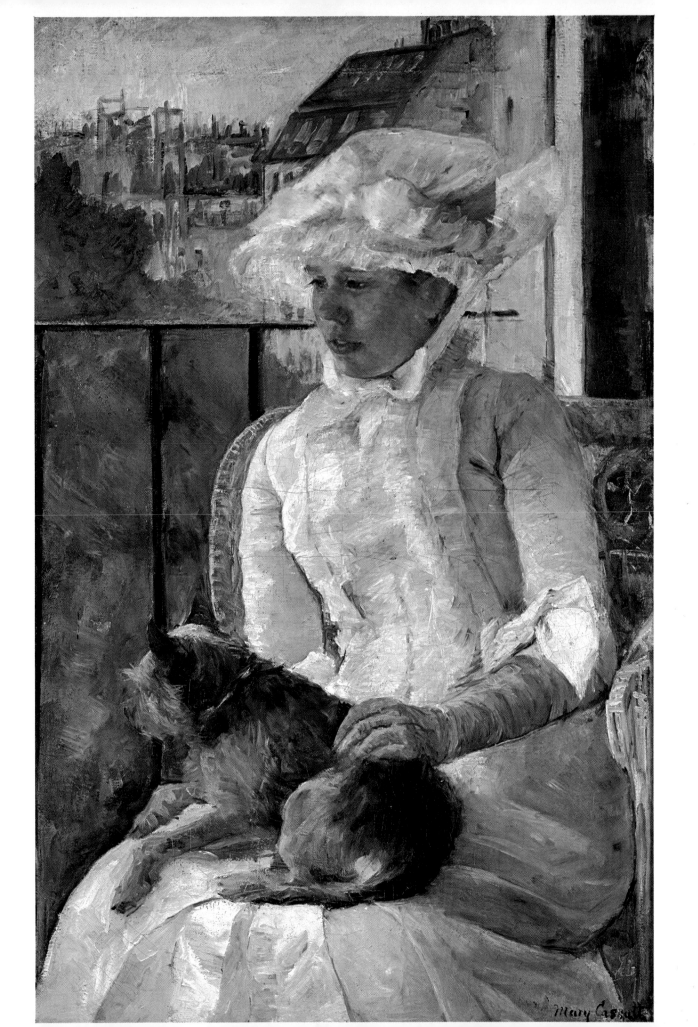

Plate 10
READING "LE FIGARO"
1883
Oil on canvas, 41″ x 33″ (104.2 x 83.8 cm.)
Collection Mrs. Eric de Spoelberch, Haverford, Pennsylvania

This painting of the artist's mother is certainly Cassatt's finest portrait. Mrs. Robert Simpson Cassatt had spoken and read French fluently since childhood and passed her Francophilia on to her children. She was an avid reader of the French newspapers, such as the Paris daily *Le Figaro*, as well as the American papers sent from Philadelphia. In 1885 Cassatt wrote her brother Alexander, who then raised thoroughbreds, "We all take the greatest interest in the racing news, Mother seizes the paper the moment it arrives, and won't give it up until she has read all about your horses." Cassatt captured just such a scene of intense concentration in this painting.

The picture displays many characteristics of the artist's style of the eighties; here they are handled with the greatest assurance. Again there is the opposition of straight and curving lines: the frame of the mirror and the edges of the newspaper versus the head and shoulders of the reader and the back of the chair. There is also the contrast of the patterned chintz covering of the chair with the flat, plain wall, against which Mrs. Cassatt's dark head is so starkly silhouetted.

The mirror has been effectively employed to break the flatness of the confining space. It not only opens up the composition, it also introduces the ambiguous quality of reflections, providing a simultaneous view of the reader's right hand. Beginning in the early eighties, hands played an increasingly important role in Cassatt's paintings, both structurally and psychologically. Hands always present a challenge to an artist's draughtsmanship. Cassatt's increasing graphic ability at this time, gained from work on her drypoints, allowed her to explore the expressive possibilities of hands. Here they are solidly modeled, firmly holding the newspaper. The figure has a substance and weight and conveys the impression of a strong and intelligent personality. The entire painting is unified by the brilliant display of Cassatt's subtle handling of the nuances of white with its gray and brown shades.

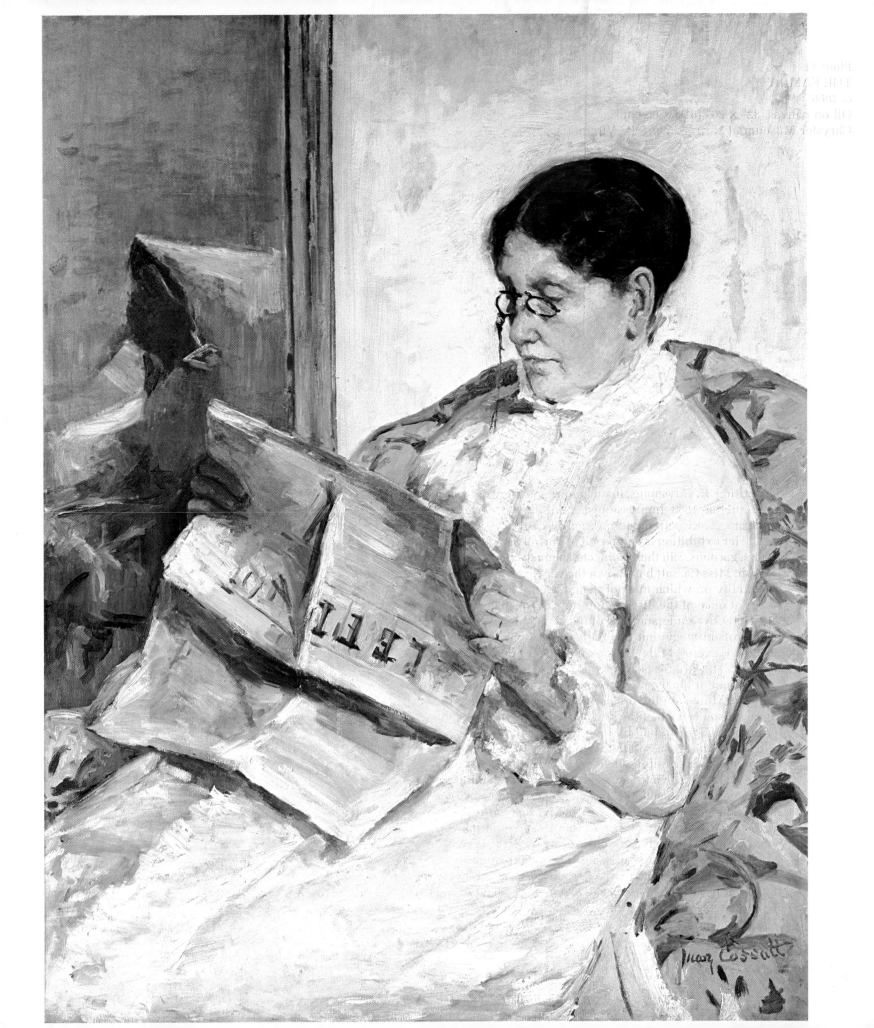

Plate 11
THE FAMILY
c. 1886
Oil on canvas, 32″ x 26″ (81.3 x 66 cm.)
Chrysler Museum at Norfolk, Norfolk, Virginia

The critic J. K. Huysmans, in an admiring review of Cassatt's work in the 1880 Impressionist exhibition (translated by Frederick A. Sweet), noted an English quality in her paintings. "Her exhibition is composed of portraits of children, interiors, gardens. . .in these subjects, so much cherished by the English, Miss Cassatt has known the way to escape from sentimentality on which most of them have foundered. . . . One thinks at once of the discreet interiors of Dickens. . . . [There is] an effective understanding of the placid life, a penetrating feeling of intimacy that one finds comparable to the Three Sisters by Everett Millais." *The Family* has some of this Englishness. The profile head of the young girl particularly is reminiscent of the female types used by such Pre-Raphaelite artists as Millais. In the preciseness of the draughtsmanship there is also the echo of the linework of Holbein, an old master admired and studied by both Cassatt and Degas.

In this painting Cassatt has used the classic pyramid composition, solidly grouping the figures together into a unified whole. While the group is posed outdoors, the landscape is only generally indicated. It does not record a specific place. As in many of her pictures, Cassatt has pushed the figures forward toward the viewer where they fill two-thirds of the composition. Although her paintings are not large in size, the figures are usually large in scale. The combination of acid green and purple was a favorite one of Cassatt's and she used it in other paintings. These bright, dark colors set off the light flesh tones and emphasize the contours of the models' bodies.

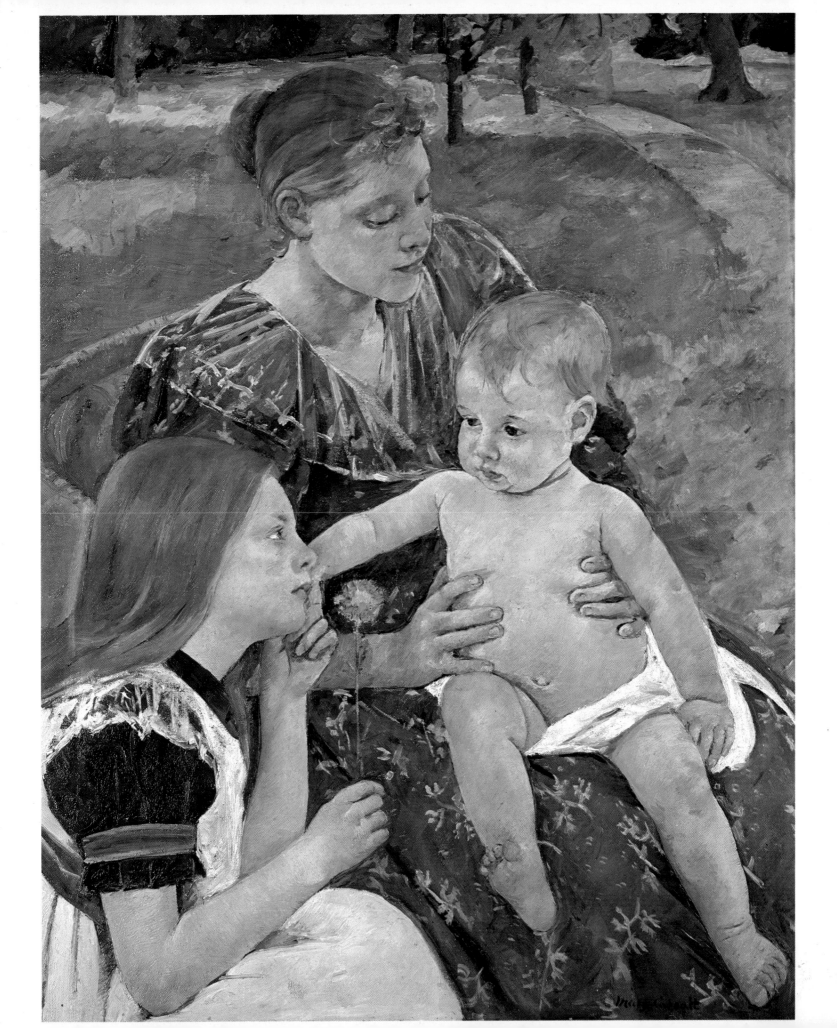

Plate 12
GIRL ARRANGING HER HAIR
1886
Oil on canvas, 29½″ x 24½″ (74.9 x 62.2 cm.)
National Gallery of Art, Washington, D.C.
Chester Dale Collection 1962

Achille Ségard, Mary Cassatt's first biographer, stated that this painting was the result of an argument between the artist and Degas. It seems that they were both viewing the pictures of a friend, whose work Cassatt thought lacked style. Degas said that women should not attempt to be critics for, "What do they know about style!" Taking this retort as a personal challenge, Cassatt painted this picture of an awkward, adolescent girl tying up her hair. She knew, as did Degas, that style did not depend on subject matter but on composition and execution. When seen in the eighth and last Impressionist exhibition in 1886, Degas exclaimed, "What drawing, what style!" He insisted on exchanging one of his pastels of a woman bathing for this picture, which remained in his collection until his death. Cassatt was obviously proud of her mentor's praise. As she later wrote to Mrs. Havemeyer (December 12, 1917) at the time of the Degas estate auction, "The Degas sale will be a sensation. I am glad that in the collection of pictures by other painters he owned I will figure honorably, in fact they thought the two, a painting [Plate 12] and a pastel, were his at first."

After 1880 Degas' most frequent subjects were nude women engaged in various stages of their toilette. A number of these objective studies were also included in the 1886 exhibition. Interested in the movement and contortions of the human body, Degas' expressed aim was to show these women "deprived of their airs and affectations, reduced to the level of animals cleaning themselves." While his women lack any individuality, Cassatt's young girl has a definite personality. She is neither pretty nor refined. Her ungainly gesture is that of a person unobserved, absent mindedly coiling her hair. Cassatt's work, however, lacks the cool detachment and clinical analysis of Degas.

The figure fills nearly half the picture and impresses itself on the viewer. The composition is simple both in structure and color. Cassatt's palette has been restricted primarily to white, lavender, and shades of rose and brown. The firm modeling of the forms gives a solidity even to the girl's cotton chemise. The stark, cool whiteness of this plain garment contrasts with the warmly colored, floral wallpaper. The arrangement of the girl's bent arms and coil of dark hair creates an "s" curve which unifies the composition.

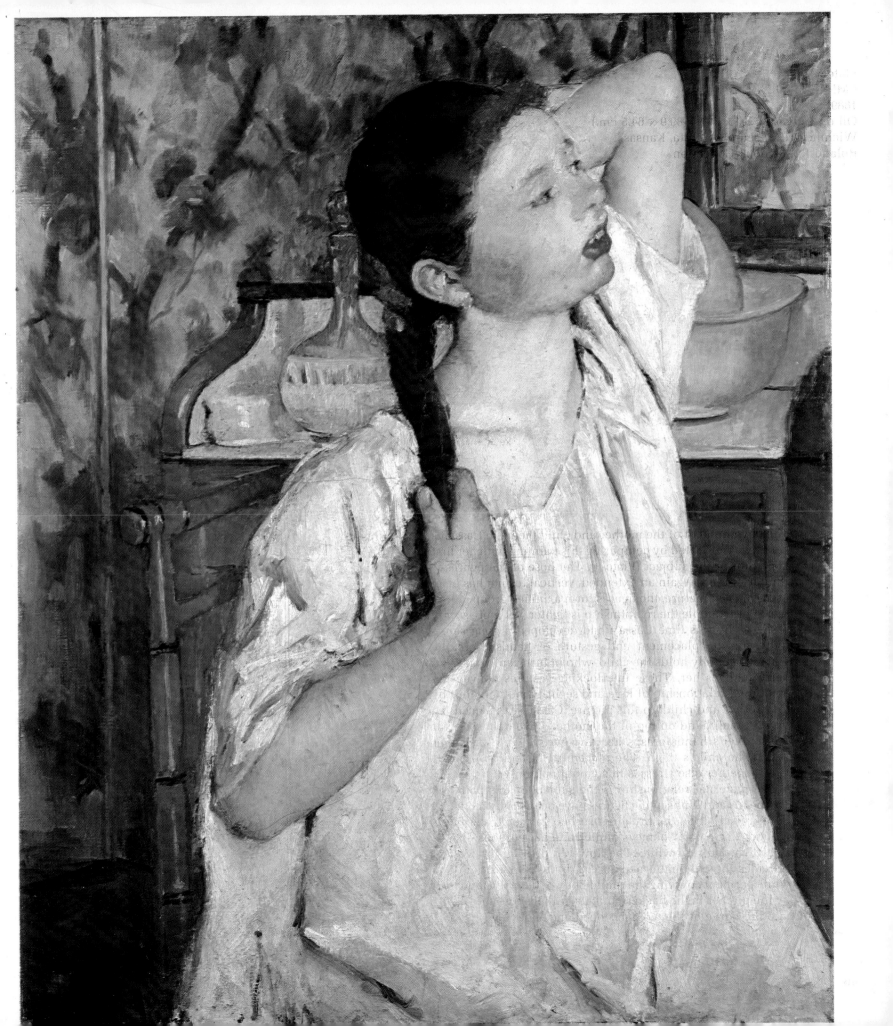

Plate 13
EMMIE AND HER CHILD
1889
Oil on canvas, 35⅜″ x 25⅜″ (89.9 x 64.5 cm.)
Wichita Art Museum, Wichita, Kansas
Roland P. Murdock Collection

The development of the mother and child theme in Cassatt's oeuvre is illustrated by comparing this painting with her first depiction of the subject (Plate 8). The pose of the figures is similar in both. Again an extended, vertical format has been used. In each picture, the figures form a unified group, but in this later example the relationship is tighter, yet more subtly realized. By this time Cassatt had developed a great sensitivity for the placement and gesture of hands. Here the woman securely holds the child, who in turn gently and tenderly touches her. These interlocking gestures convey the emotional relationship of love and security mutually felt by the mother and child. In this picture, Cassatt has placed the baby's small hand on top of the mother's two hands; one of the mother's hands grasps her own wrist, while the other grasps the child's thigh. The placement of their two heads close together also stresses this emotional unity.

The maternal relationship is the subject of this painting. The heads and limbs of the figures have been firmly modeled; they are set off by the broadly brushed garments and background. The color scheme is limited and harmonious: shades of brown, red, and white. The flowered dress of the woman provides the only patterned accent in the composition. The white garment covering the round body of the baby is echoed by the pitcher in the background; its bulbous form neatly fits into the curve of the woman's head and shoulder.

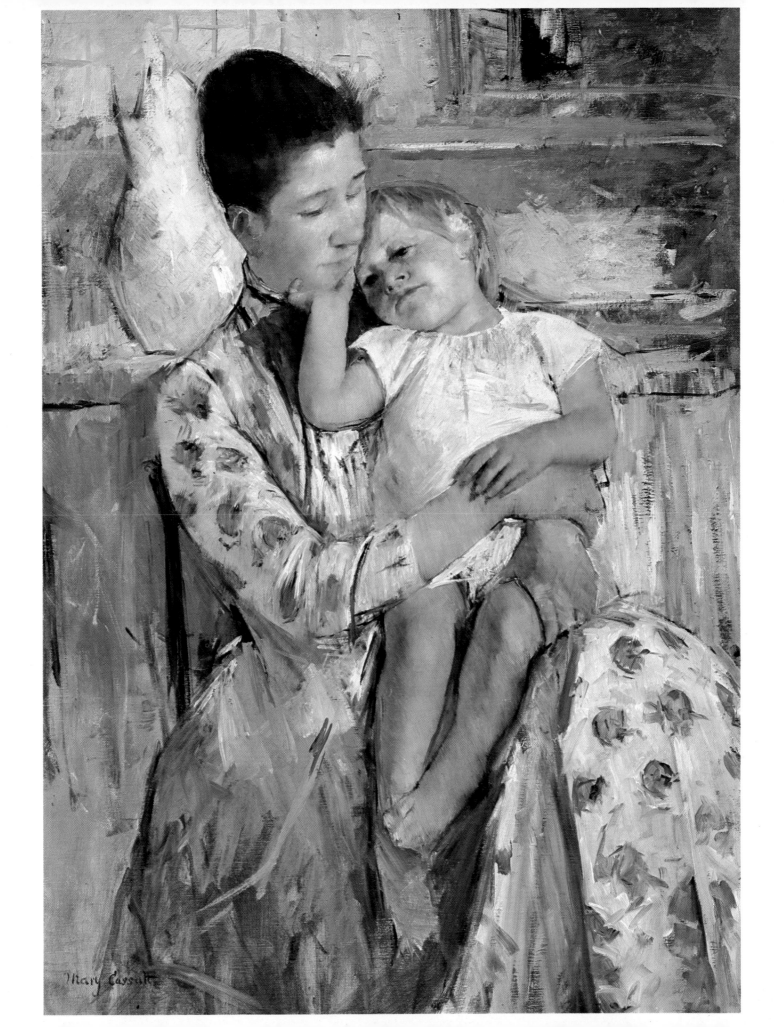

Plate 14
MRS. ROBERT SIMPSON CASSATT
c. 1889
Oil on canvas, 38″ x 27″ (96.5 x 68.6 cm.)
Collection Mrs. Gardner Cassatt, Villanova, Pennsylvania

This painting of the artist's mother was done about six years after *Reading "Le Figaro"* (Plate 10). Now nearly seventy-three, Mrs. Cassatt had suffered from heart trouble and rheumatism for a number of years. Rather than the strong intensity of a person absorbed in her newspaper, Cassatt here has captured the resignation and contemplation of old age with great sensitivity. Characteristically, Mary Cassatt's finest portraits were of subjects she knew intimately. Obviously this painting is an expression of her deep devotion and love of her mother.

Mrs. Cassatt stares into space, one hand supporting her head, the other grasping a balled-up handkerchief. The figure has been placed in the center of the composition; the pyramidal shape stabilizes the picture. The face and hands are strongly modeled with short, regular brushstrokes which follow the contours of the forms. In contrast, the rest of the picture is broadly brushed. Some areas, such as the shawl and lower left corner, have been left unfinished with the white canvas showing. This sketchy quality of execution gives a fresh and spontaneous feeling to the picture. The inspiration of Manet is still apparent in the rich nuances of the black dress and the vigorous and lively brushwork which summarily defines the bouquet of flowers and the picture.

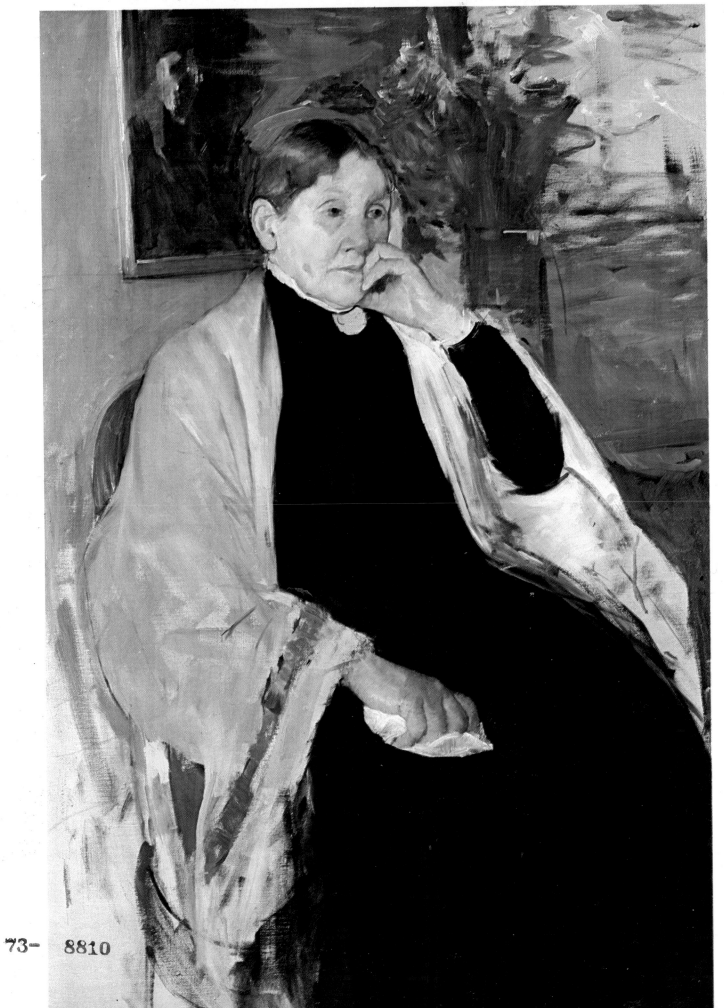

Plate 15
BABY'S FIRST CARESS
1891
Pastel on paper, 30″ x 24″ (76.2 x 61 cm.)
New Britain Museum of American Art, New Britain, Connecticut
Harriet Russell Stanley Fund

The complex, interlocking gestures seen in *Emmie and Her Child* (Plate 13) are used similarly in this simpler pastel. The baby touches the woman's face above, while she in turn holds his foot directly below. The two gestures are connected by the straight line formed by the child's arm and lower leg which divides the composition in half. The compact, pyramidal shape of the two figures is set against the plain background. The curve of the outer arms of the woman and child define the sides of the picture while enclosing its center. Again the heads are placed together; the direct glances further unite the two figures.

Cassatt has applied the pastel in parallel, diagonal strokes. The baby's body has greater weight and form due to the shortness and closeness of these strokes, compared to the more broadly defined area of the woman's dress. The cool coloring of her garment and the gray background contrast with the rosy flesh tones of the naked child. As is characteristic in Cassatt's use of this medium, the original underdrawing is first obliterated by the pastel strokes, while later many of the contour lines—along the right side of the baby's arms and legs—are redefined with dark chalk.

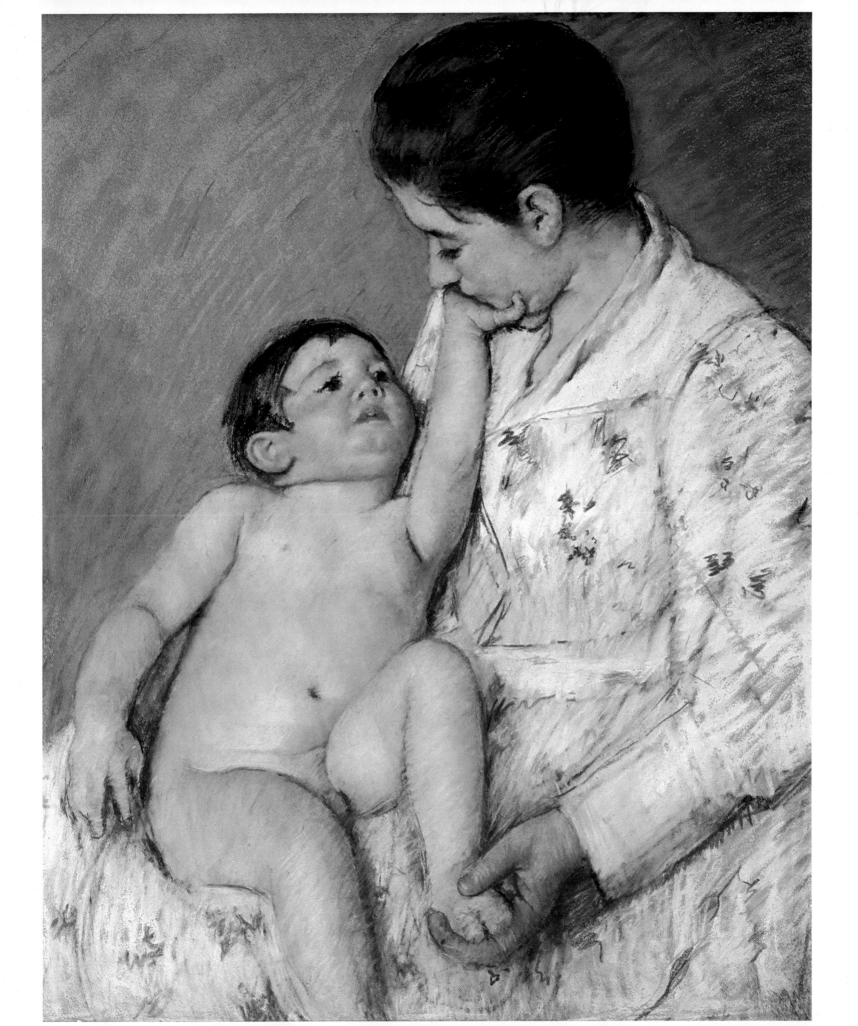

Plate 16
THE BATH
1892
Oil on canvas, 39½" x 26" (100.4 x 66 cm.)
The Art Institute of Chicago, Chicago, Illinois
Robert A. Waller Fund

The great exhibition of Japanese art held at the *Ecole des Beaux Arts* in 1890 had a strong impact on Cassatt's work. Inspired anew by the hundreds of Japanese wood-block prints exhibited there, she immediately began work on the set of ten color aquatints. In such prints as *The Letter*, she was able to capture the simplicity and refinement of the orient. Unlike her drypoints, which were based on previously painted compositions, the aquatints depicted original subjects.

The Bath, one of Cassatt's finest pictures of the nineties, probably captures most successfully in paint the qualities found in her aquatints. Her frequently used, extended vertical format, reminiscent of similarly shaped Japanese prints, is accentuated by the long, straight legs and arms of the figures. The scene is observed from above, a type of oriental perspective often used by Degas. This angle gives the viewer the feeling of hovering over the figures. Rich patterns—the flowered wallpaper and painted chest, the geometric rug, and, especially, the broadly striped dress—surround the child, stressing the plain mass of her body. The forms are closed, divided into compartments by the strong contours.

With color, Cassatt has separated the composition into two parts: the generally pink and white area of the figures and the surrounding red and green of the carpet and background. The figures are interlocked by their gestures: the woman's hand holding the child's foot and the coinciding of their two hands at her knee. The oval created by their adjacent heads repeats the round basin below; the two shapes are connected by the diagonal formed by the child's arm and leg. The large pitcher pins down the composition and acts as a focal point; the pitcher is further emphasized by the stripes of the woman's dress which seem to radiate from it. Similar pitchers are prominently used by Degas in many of his paintings of of bathing women.

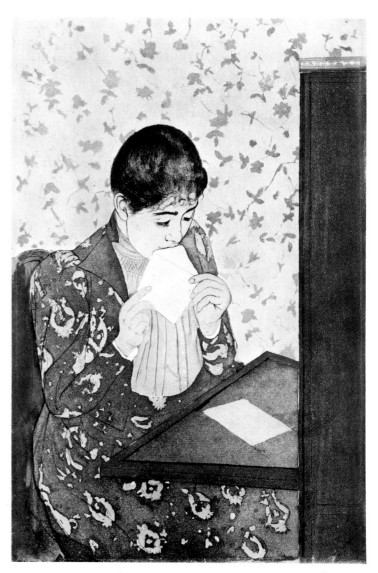

The Letter, *1891, soft-ground etching drypoint, and aquatint in color, 13⅝"x9", National Gallery of Art, Washington, D.C., Rosenwald Collection.*

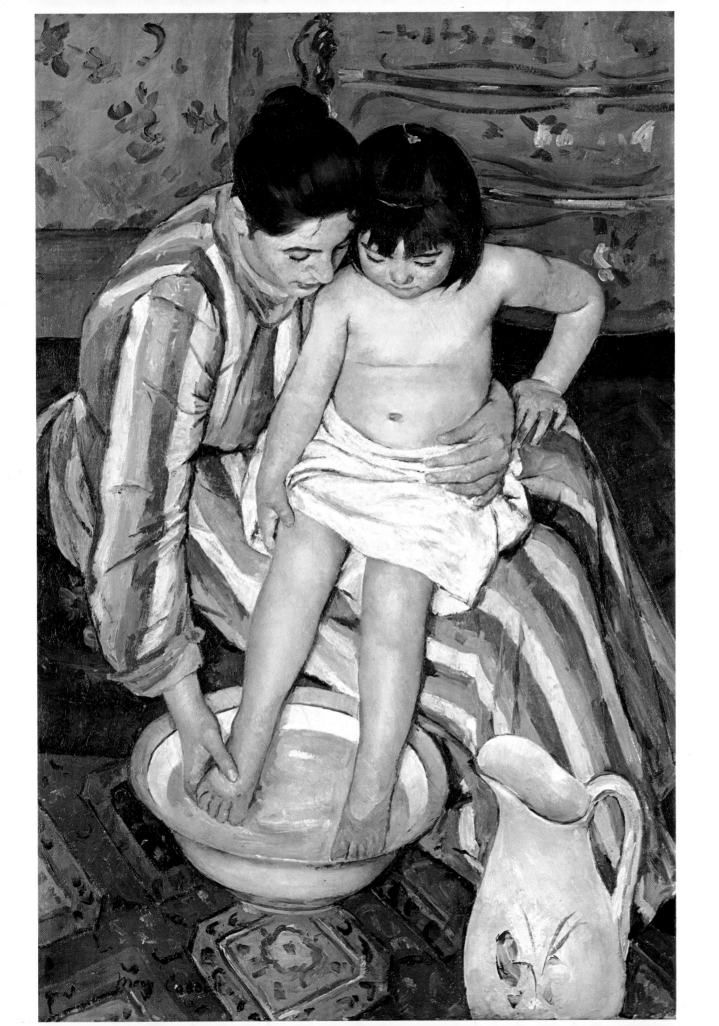

Plate 17
BABY REACHING FOR AN APPLE
1893
Oil on canvas, 39″ x 25½″ (99.1 x 64.8 cm.)
Collection Mrs. Blaine Durham, Hume, Virginia

In the fall and winter of 1892 Cassatt worked on her mural for the Woman's Building of the Chicago World's Columbian Exposition. Her subject was "Modern Women." In the mural's center she depicted *Young Women Plucking the Fruits of Knowledge and Science.* Although this title has the allegorical ring of the Academy, the picture was a realistic scene of women and children picking apples. Unfortunately the mural has disappeared and only a vague idea of its appearance is conveyed by contemporary photographs. In its subject and coloring this painting is closely related to the mural and may even be a study for a background figure in the mural's central panel. If this picture is an indication of the quality of Cassatt's mural, its loss is even more unfortunate.

This painting—as does *The Bath*—reflects the inspiration of the 1890 exhibition of Japanese art. The contrasting areas of pattern and color, the flattening of space, and the strong contours derive from Cassatt's renewed study of Japanese prints. These elements are found in her earlier work, for she had known these prints since the late seventies, but here they are used with greater boldness. The severely limited color scheme of green and pink is particularly striking. The floral pattern of the woman's dress echoes the branches of the apple tree above. Again the relationship of hands is important: both those of the woman and child converge on an apple, making it the center of interest in the composition. While there is a distinct lack of spatial recession in this picture, the weight and pressure of the baby on the woman's arm is convincingly rendered.

This picture, like the mural, was painted in Cassatt's country studio at Château Bachivillers. While the artist dressed her models in expensive gowns from the leading Paris couturiers, the women themselves were farm girls from the surrounding countryside. Cassatt preferred these plain, young women to professional models, who she felt could not properly hold a baby. Mrs. Ernest G. Stillman, daughter-in-law of James Stillman, later wrote that Cassatt sought in such paintings, "the rhythm of the constantly curving arm, the constantly bending back. She found it in those French women of the soil, stooping over their firm-bodied children."

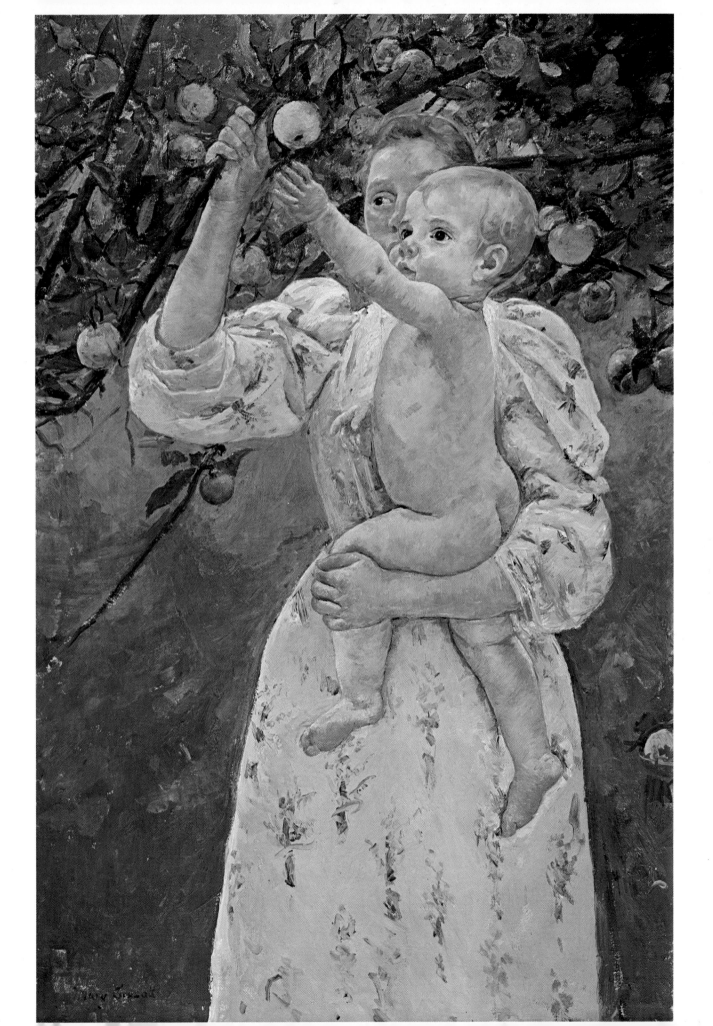

Plate 18
THE BOATING PARTY
1893/94
Oil on canvas, 35½" x 46⅛" (90.2 x 117.2 cm.)
National Gallery of Art, Washington, D.C.
Chester Dale Collection 1962

After completing her mural for the Chicago World's Fair, Cassatt vacationed in early 1893 on the Riviera, at Antibes. There she began this painting, one of her largest and most ambitious works. The subject was probably suggested by a similar work by Edouard Manet of a man and woman in a boat which was exhibited at the 1870 Salon (*Boating*, The Metropolitan Museum of Art). Cassatt was later instrumental in acquiring the Manet painting for the Havemeyers, referring to it then as "the last word in painting."

Rather than having the man face forward in the boat, as in Manet's picture, Cassatt posed her male model in the foreground with his back to the viewer. The center of her composition is the child, held on the woman's lap. The angle formed by the man's straight arm and the oar points directly at the baby. The curves of the boat's sides and the point of the sail also directs attention to the child. The foreground and background are connected by the line formed by the arms of the man and woman and the top edge of the sail. In addition the figures are psychologically connected by their glances; the mother and child gaze at the man who stares back.

The influence of Japanese prints is most apparent in the general simplicity of the composition. All extraneous details have been eliminated. The figures and parts of the boat are separate units, clearly defined by the sharp contours and solid areas of color. In comparison with Manet's broadly brushed and sketchy painting, the forms here are evenly modeled and smoothly brushed. The abrupt cropping of the boat at the bottom and right side has the effect of projecting it outwards toward the viewer, giving him the sensation of being a passenger. The use of a high horizon is also a Japanese convention; it allows the boat and occupants to be silhouetted against the blue sea. By her use of vivid and contrasting colors and suppression of shadows, Cassatt has created the illusion of brilliant sunlight.

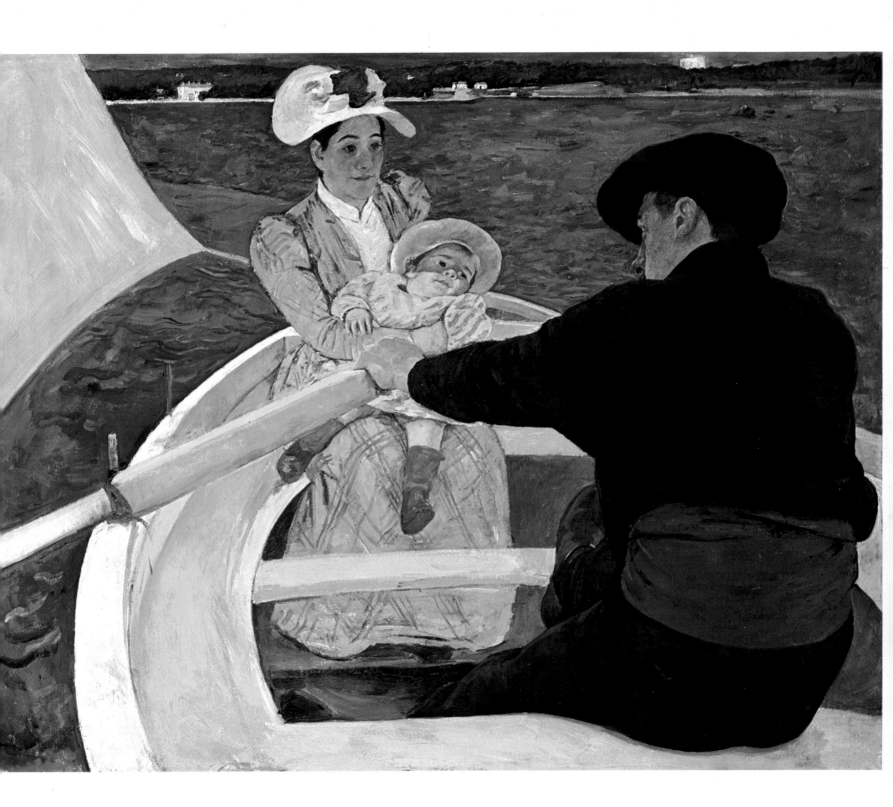

Plate 19
SUMMERTIME
1894
Oil on canvas, 29″ x 38″ (73.7 x 96.5 cm.)
The Armand Hammer Foundation, Los Angeles, California

Compared to the solidity and tightness of *The Boating Party*, this painting has the freshness of a rapidly executed sketch done on the spot. Probably painted during the second summer at her recently purchased Château de Beaufresne, it may represent the large pond behind the house. If so, the scene is similar to the one Cassatt later described to the wife of her nephew, Robert. "I am now painting with my models in the boat and I sit on the edge of the water, and in these warm still September days it is lovely; the trout leaping for flies and when we are still we can see them gliding along. The whole beauty of the place is in the water."

This subject must have fascinated the artist, for she painted another version of it at this time: two women and a child feeding ducks from a boat (*On the Water*, Art Institute of Chicago), which she copied in a color aquatint in 1895. Later in 1901 and 1908, she did two larger, more ambitious paintings of similar scenes. Berthe Morisot was also attracted to this subject on several occasions and exhibited one sketchy oil in her 1892 one-woman show in Paris (*Girl in a Boat with Geese*, National Gallery of Art, Washington).

Cassatt has perfectly captured the coolness of such an afternoon scene by the extensive use of blue and green. The paint has been applied broadly, leaving some of the canvas to show through. The renewed Japanese influence in her work is seen here in the high horizon, caused from viewing the subject from above, and the asymmetrical arrangment of the composition caused by the placement of the boat at the right, cut by the frame.

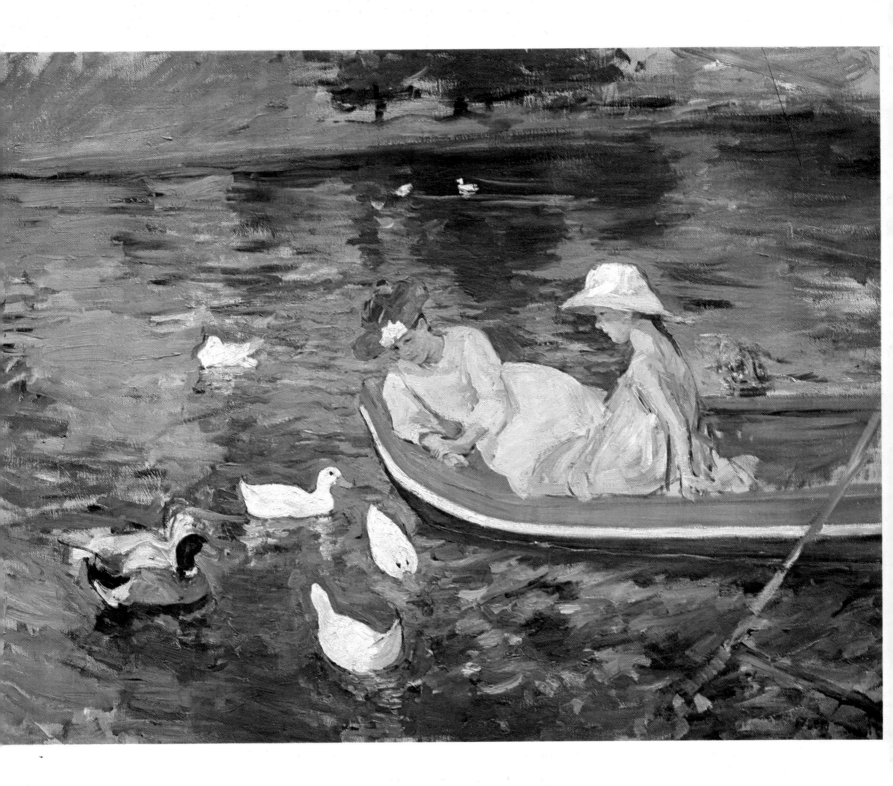

Plate 20
ELLEN MARY CASSATT IN A WHITE COAT
1896
Oil on canvas, 32″ x 24″ (81.3 x 61 cm.)
Private Collection

At the time of her mother's death in late 1895, the artist's younger brother, Gardner, and his family came to Europe for a two year visit. During the first winter they stayed at her Rue de Marignan apartment in Paris, where Cassatt probably did this portrait of her niece, Ellen Mary, who was then about two years old,

The picture at times has been called, appropriately, *The Little Infanta*. The stiff, regal pose, serious expression, and elaborate costume recall the portraits of Spanish princesses by Velázquez. The somber color scheme of white and brown is accentuated by the golden yellow upholstery. The composition, purged of all unessential detail, is unified by the sinuous line of fur trimming in the child's coat and bonnet which winds across the picture and around the figure. This complex, serpentine curve is structurally balanced by the straight lines of the background and chair which frame and stabilize the figure. The general flatness of the forms is relieved by the small, roundly modeled face of the child. This lack of spatial recession and the emphatic use of outlines to compartmentalize forms are seen in Japanese prints.

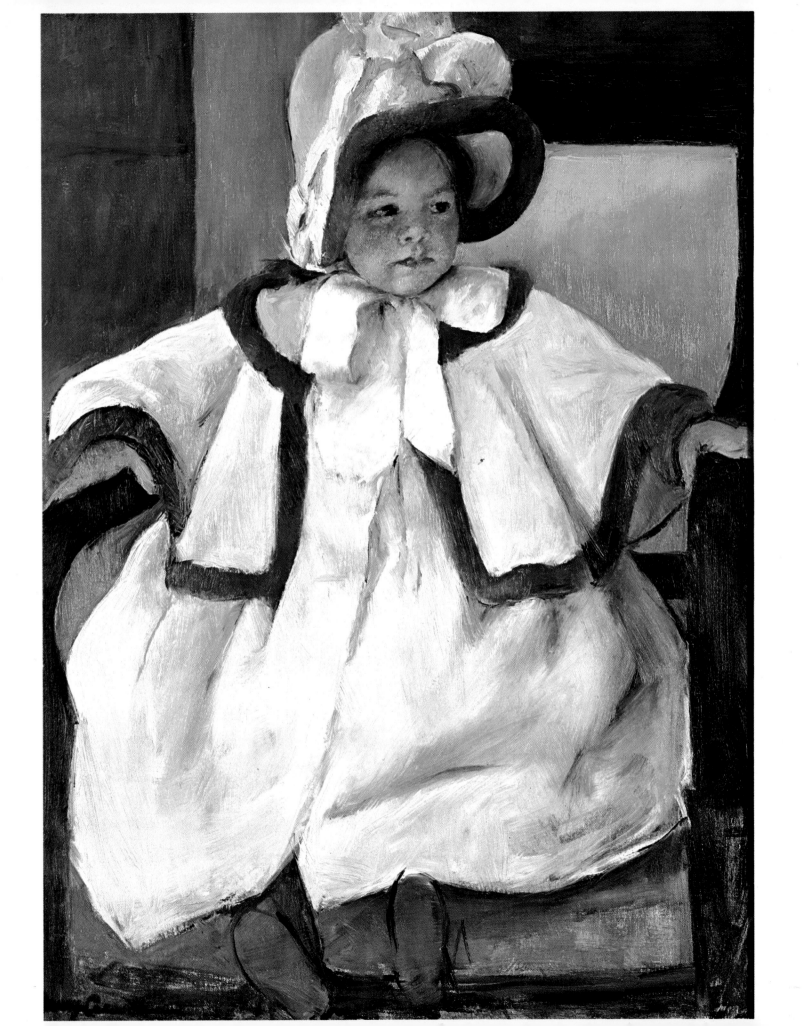

Plate 21
BREAKFAST IN BED
1897
Oil on canvas, 25⅝" x 29" (65.1 x 73.7 cm.)
Collection of Dr. and Mrs. John J. McDonough, Youngstown, Ohio

This is perhaps Mary Cassatt's most tender and intimate depiction of the maternal theme. All the characteristics of her mature style are seen in this picture. Her vocabulary of expressive gestures is used to organize the composition in a complex and subtle manner. The alert, preoccupied child is encircled by the arms of his sleepy mother. This closely knit group is placed in the center of the picture. The diagonal formed by the woman's arms and child's outstretched legs divides the picture in two unequal parts. The curving bulges of the white sheets and pillows, as well as the garments, envelop and highlight the heads and limbs of the figures. The dominating scheme of white and rosy flesh tones is emphasized by squares of apple green in three corners which, in their angularity, frame and stabilize the composition. Again still life elements provide an important accent in the picture; the round forms of the cup, saucer, and tray repeat the shapes of the two adjacent heads.

About this time Cassatt was attempting to break away from the tightly modeled and compartmentalized forms of the early nineties, as seen in *The Boating Party* (Plate 18). While drawing still plays an important role in this painting, there is a general loosening of the forms. Cassatt has broken many of the contour lines with short, smudgy brushstrokes, for example, along the division between the baby's legs. This crosshatching effect is similar to her handling of pastel. The more painterly approach is seen particularly in the varied areas of white, where the use of blue highlights activates the broadly brushed surface.

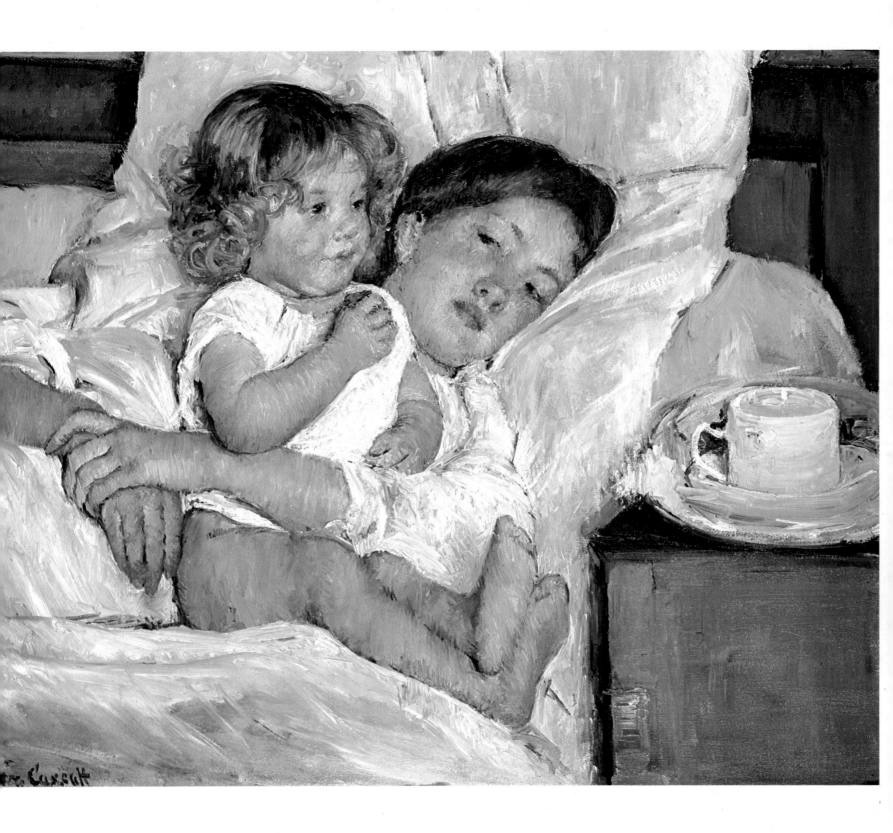

Plate 22
GARDNER AND ELLEN MARY CASSATT
1899
Pastel on paper, 25″ x 18¾″ (63.5 x 47.6 cm.)
Collection Mrs. Gardner Cassatt, Bryn Mawr, Pennsylvania

In the fall of 1898 Mary Cassatt visited America for the first time in twenty-five years. She found the Atlantic crossing uncomfortable, suffering violently from sea sickness. This condition prevented further trips home, except for one final visit in 1908. While in America she received several commissions, executing pastel portraits of members of the Hammond and Whittemore families, primarily young children. Staying with her younger brother, Gardner, in Philadelphia she also did portraits of his two children, including this double one of young Gardner and Ellen Mary.

By this time most of Cassatt's pictures are marked by great simplicity and directness. Details of costume and background are suppressed, focusing the viewer's attention on the faces of her sitters. The background is generally plain and flat, and the figures are compactly grouped and silhouetted against it. The color scheme is also simplified; usually there are two dominant colors, with a contrasting third one as an accent—in this case, green and brown with pink.

In this pastel, Cassatt has again conveyed the emotional relationship existing between two people. Gardner's arm encircles his young sister; their hands touch at the lower left. Ellen Mary is relaxed and vulnerable, leaning back against her brother, who sits erect with a strong and determined expression on his face. This picture illustrates perfectly the ideal older brother-younger sister relationship of protection and dependence. It is a type of female-male relationship which Cassatt never attempted with adult subjects. In fact, except for her brothers and father, she almost never depicted men.

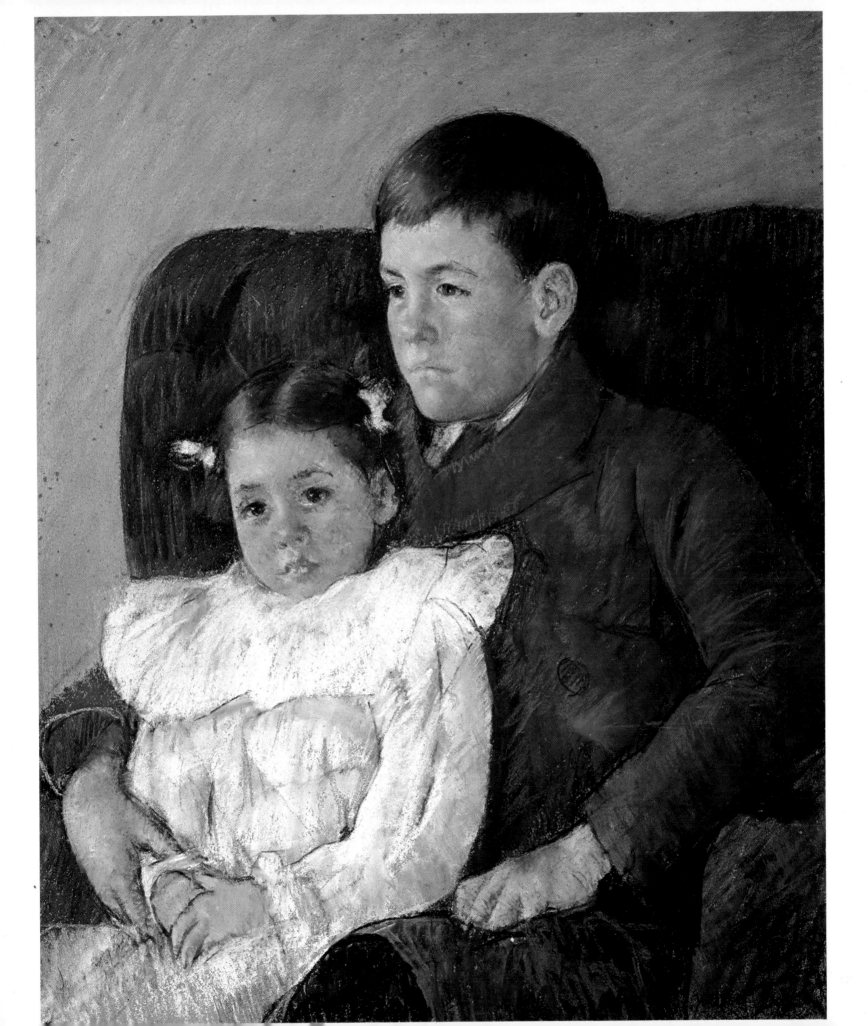

Soon after her return to Paris from America in March 1899, Cassatt executed this triple portrait of the daughter of Paul Durand-Ruel and her children. Durand-Ruel, the artist's dealer throughout her career, was a close friend and this picture was probably a gift rather than a formal commission. In later life the two girls both married noblemen: Madeline, the oldest, became the Comtesse de Brecey, while Thérèse became the Vicomtesse de Montfort.

This portrait is similar, both in composition and color, to the group of pastels Cassatt did of children while in America. Here the simplicity of her palette is particularly striking: the bright blue and pink set off by the dark accents of the sitters' hair. The longer, horizontal format was one Cassatt used several times around 1900. Attracted by their intense gaze, the viewer's attention moves from face to face across the picture and down to the two hands at the right. The sweet colors and the conventional prettiness and rather vapid expressions of the sitters convey no idea of their individual personalities. In such a picture, Cassatt is unfortunately close to the dull, fashionable portraiture of the period.

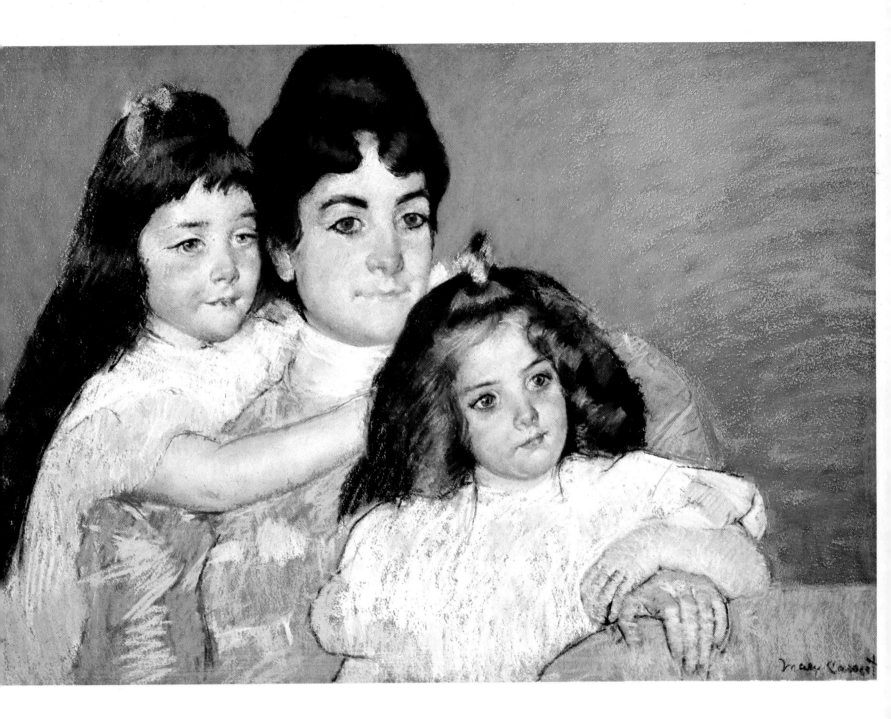

Plate 24
AFTER THE BATH
c. 1901
Pastel on paper, 25¾" x 39¼" (65.4 x 99.7 cm.)
The Cleveland Museum of Art, Cleveland, Ohio
Gift of J. H. Wade

The arrangement of the three figures across the extended, horizontal format of this pastel creates the effect of a sculptural frieze. The flat, confined space of the picture also contributes to this impression. The center of the composition is defined by a square formed by the interlocking limbs of the three figures: the side of the baby's body, his arm held by the young girl, the coinciding arms of the woman and girl, and the woman's forearm, parallel to the frame's bottom edge. These gestures are, however, purely structural, expressing little emotional relationship between the figures.

After 1900 Cassatt repeatedly used the same models in her pictures. In this way she attempted to achieve an intimacy and familiarity with her subjects, as found in her earlier family portraits. These three models, particularly the young girl known as Sara, appear frequently in her work at this time. In the pastels of this period, Cassatt partially abandoned the discipline of line which marked her earlier work. The chalk is applied more freely than before in large, broken strokes. A similar abandonment of form is seen in Degas' work of the same years, due to his increasing blindness.

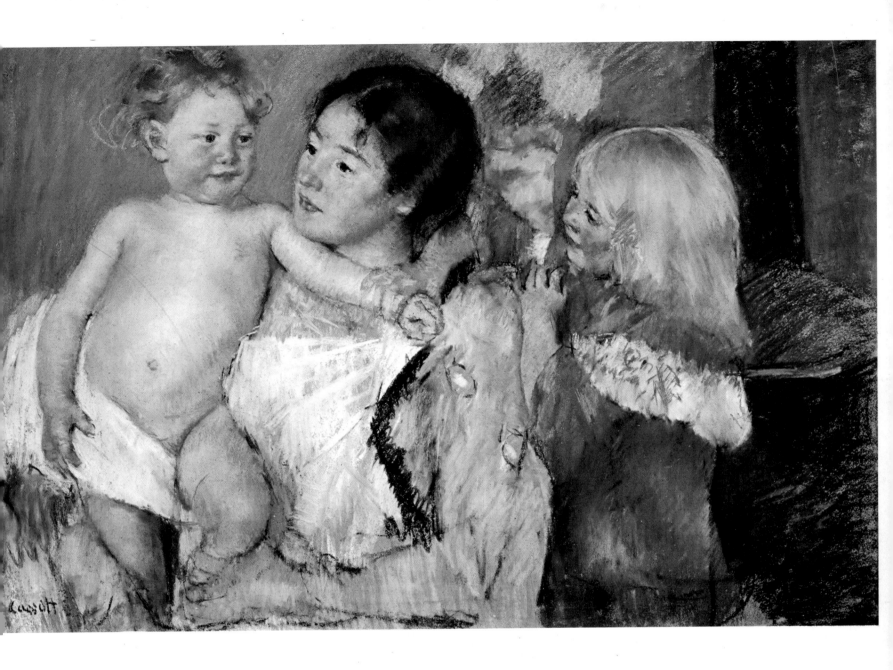

Plate 25
REINE LEFEBVRE HOLDING A NUDE BABY
1902
Oil on canvas, 26⅞" x 22½" (68.3 x 57.1 cm.)
Worcester Art Museum, Worcester, Massachusetts

Degas said of a similar maternal picture by Cassatt of this period, "It has all your qualities and all your faults. It is the baby Jesus and his English nanny." Although Cassatt continued to depict this subject in varied and original forms after 1900, the inherent tenderness of the subject appeared to many people—then and now—sentimental and cloyingly saccharin. The happy, fat babies and plain, dull-looking country girls in these later pictures do not project distinctive personalities or strong character. The success of these works depends less on the now familiar subject, more on the quality of design and execution.

In this painting, as in many of this decade, Cassatt has almost reduced her mature style of the eighties and nineties to a formula. We see the same tightly knit unit, the woman and child, dominating the flat, enclosed space. The interlocked gestures of the figures unite the picture in a curving rhythm of line and form. The color scheme is subtle, limited primarily to shades of tan and brown with bright accents of red. All these stylistic traits have become by this date in Cassatt's career predictable conventions, as can be seen when this painting is compared to the more original and inspired *Breakfast in Bed* (Plate 21). This is not to say that this painting lacks quality or sensitivity. But in Cassatt's work after 1900, there is a lessening of the creative force of the earlier decades. She still did fine paintings, such as this, but few great ones.

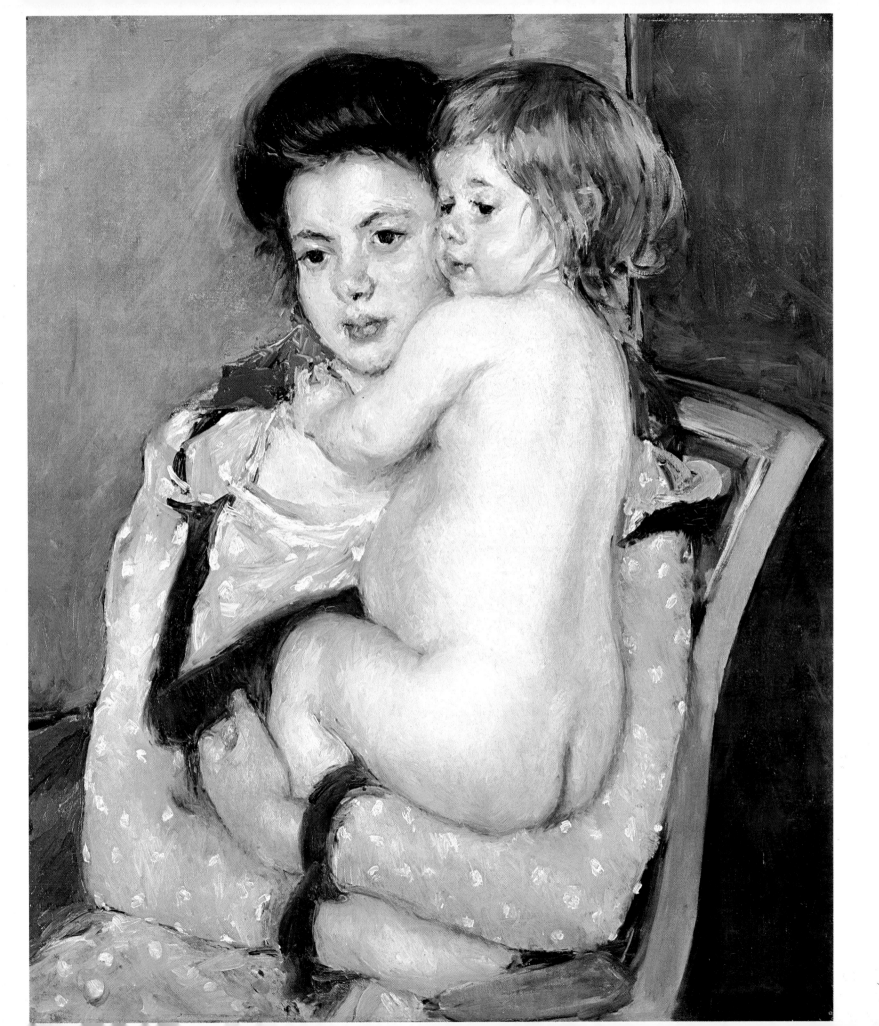

Plate 26
MARGOT IN BLUE
1902
Pastel on paper, mounted on canvas, 24″ x 19⅝″ (61 x 49.8 cm.)
The Walters Art Gallery, Baltimore, Maryland

In 1901 Cassatt began a series of pastels of little girls posed alone against plain backgrounds. These proved to be quite popular with collectors and she produced a number of them during the next few years. She even allowed the dealer Ambroise Vollard to have counterproofs of over a dozen of these subjects made, probably around 1906. A counterproof is made by running the original pastel, covered with a sheet of dampened paper, through a lithographic press. The chalk design of the original is thus partially transferred and then both versions are reworked by the artist.

The model for this picture, Margot Lux, was a young girl from the neighborhood of Mesnil-Théribus whom Cassatt used on numerous occasions. She is typical of the type preferred by the artist: round face, bright eyes, small nose, and Cupid's bow mouth; in a word, cute. The pastel in these works is applied vigorously in slashing, scribbled strokes which activate the surface but do not describe the forms. Most of the visual interest is concentrated in the fancy and colorful costumes the girls wear. The palette is limited to a few colors, usually one quite bright, in this case a vivid blue, which accents the neutral tones of white, gray, and brown. While these studies of little girls are often charming, even captivating, they lack the force and strength of her earlier, more serious work.

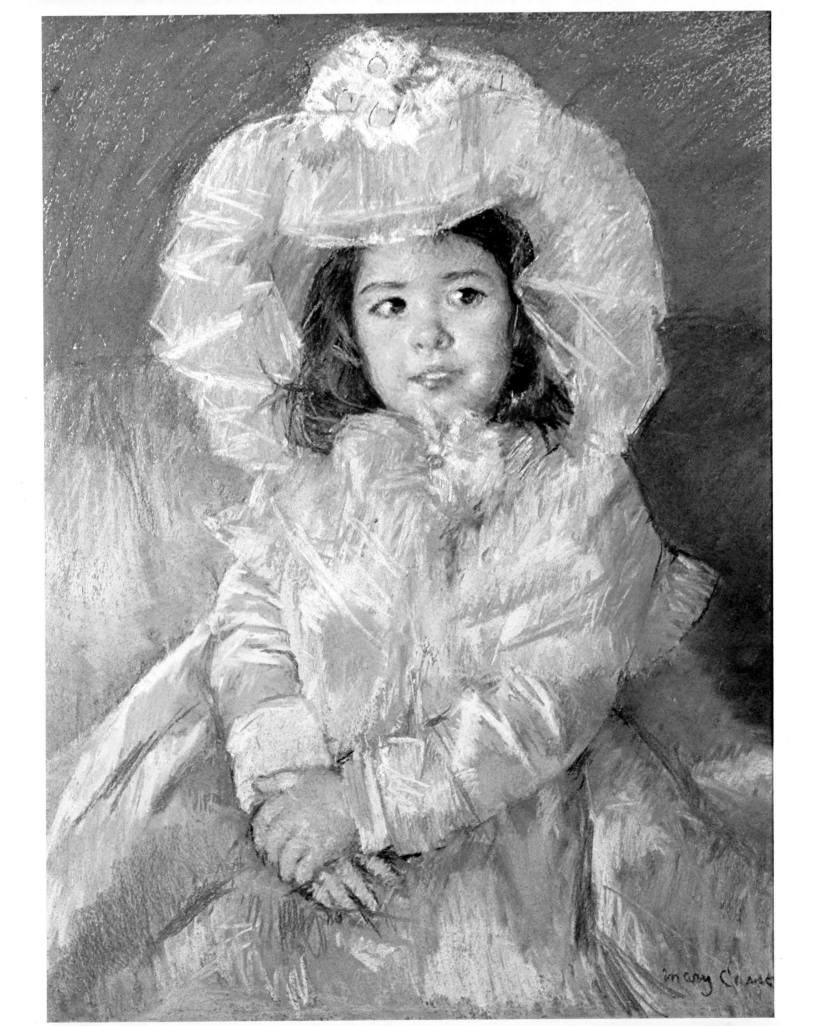

Plate 27
SIMONE IN A WHITE BONNET
c. 1903
Pastel on paper, 25½″ x 16½″ (64.8 x 41.9 cm.)
Collection Mr. and Mrs. Dale H. Dorn, San Antonio, Texas

This is another of Cassatt's popular studies of little girls, again featuring a model from the Oise countryside whom she depicted at least twenty times. One reason the artist preferred these girls of four or five was that they were well-behaved and able to hold a pose for an extended period. As she rather peevishly wrote Mrs. Havemeyer (March 8, 1909?) about one of her subjects, "It is not worthwhile to waste one's time over little children under three who are spoiled and absolutely refuse to allow themselves to be amused and are very cross. . . . It is not a good age, too young and too old, for babies held in the arms pose very well."

Certainly her compositions were not designed to tax the nerves of her young models. Always preferring scenes of inactivity, Cassatt usually depicted these girls sitting still, their hands neatly folded in their laps. The energy and excitement of childhood never interested her. This was probably the natural preference of a woman who, though she loved them, never had noisy children of her own.

The sketchy nature of this work, with its brown paper working as another color, illustrates Cassatt's pastel technique. First she quickly drew in the general outlines of the composition in dark chalk. These lines were then covered over with different layers of pastel which were more thickly applied in some areas, usually the face. Then Cassatt went back over the design, again with dark chalk, and reinforced and strengthened the major contours in the composition.

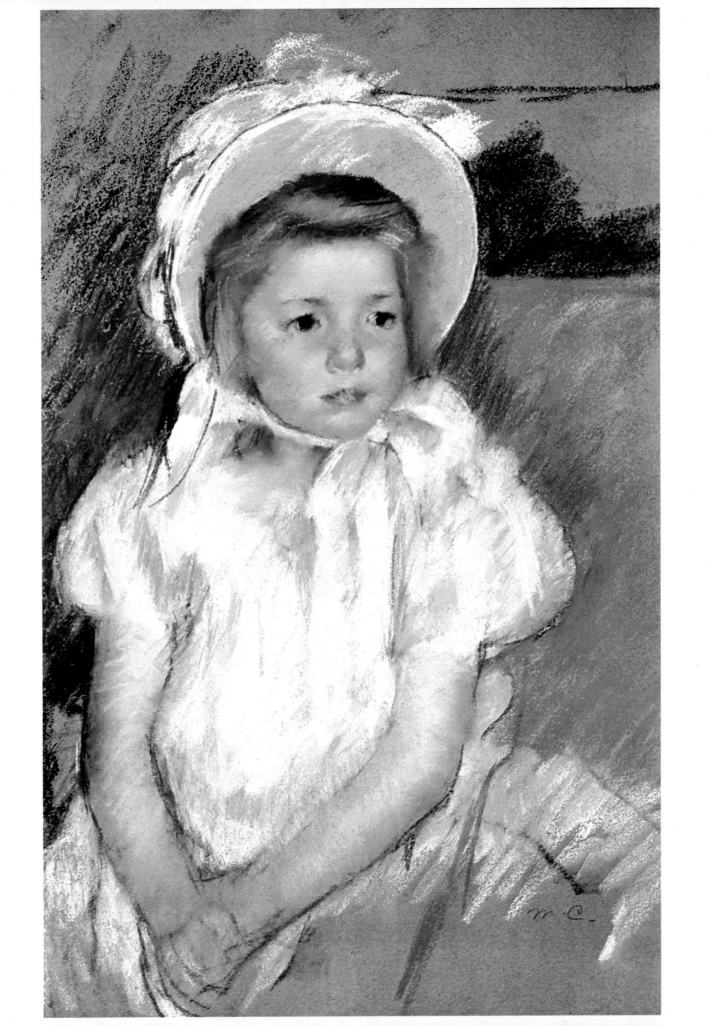

Plate 28
MOTHER AND CHILD
c. 1905
Oil on canvas, 36¼″ x 29″ (92.1 x 73.7 cm.)
National Gallery of Art, Washington, D.C.
Chester Dale Collection 1962

This is one of Cassatt's most original variations on the maternal theme during the 1900's. While mirrors appeared in her work from the beginning, a mirror is especially important in Cassatt's late works, such as this, where it breaks and extends the confined, flat space of the composition. The striking use of a second, small mirror held against the larger one creates an ambiguous and contradictory effect.

As in many of her most successful pictures, Cassatt here has opposed curved and straight forms. The shapes of the heads and their mirrored reflections, the hand mirror, and the sunflower on the woman's dress are set against the straight lines of the chair and frame of the wall mirror. These opposing elements connect and cross all over the painting in a complex and subtle way. Particularly effective are the lines of the arms leading the eye of the viewer to the hand mirror. The glances of the figures toward this object and the child's own reflection in it make the hand mirror the center of the whole design. While the forms have weight and solidity, the modeling is fuzzy, particularly the undefined grouping of hands at the left. In her earlier work such forms would have been precisely modeled and accentuated. A drypoint of this composition also indicates a similar decline at this time in Cassatt's powers as a draughtsman.

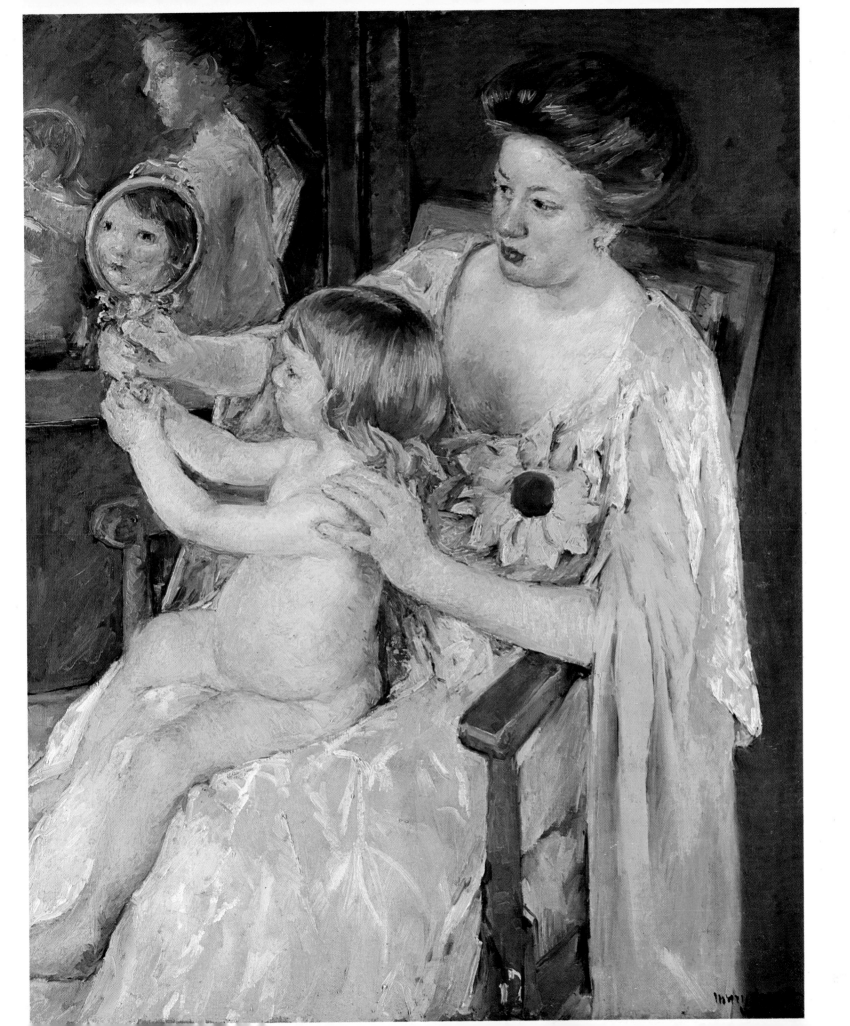

Plate 29
FRANCOISE HOLDING A LITTLE DOG
c. 1908
Pastel on paper, 25¼" x 21" (64.2 x 53.3 cm.)
Henry E. Huntington Library and Art Gallery, San Marino, California

Mary Cassatt first kept Belgium griffons in the early seventies and they appear in her pictures throughout her career (Plates 2, 9). In the years after 1914, when ill health and increasing blindness prevented her from working, these little dogs were her constant companions. George Biddle, who visited the artist frequently during this period, remembered them vividly. "My ring at the door was answered by the barking and scampering of the ill-natured and overfed griffons who lived with Miss Cassatt. Their churlish yappings would finally subside to an asthmatic wheeze when the tea had been brought in; and they would settle like withered chrysanthemums upon the rugs."

This seems an apt description for the small animal seen here. In fact, its rather comical ferocity conveys a stronger and more interesting personality than that seen on the stereotyped face of the child. One of the problems with Cassatt's late work is the dull, uninteresting models she preferred to depict. These young, inexperienced girls have only bland, chubby faces, as yet unmarked by life.

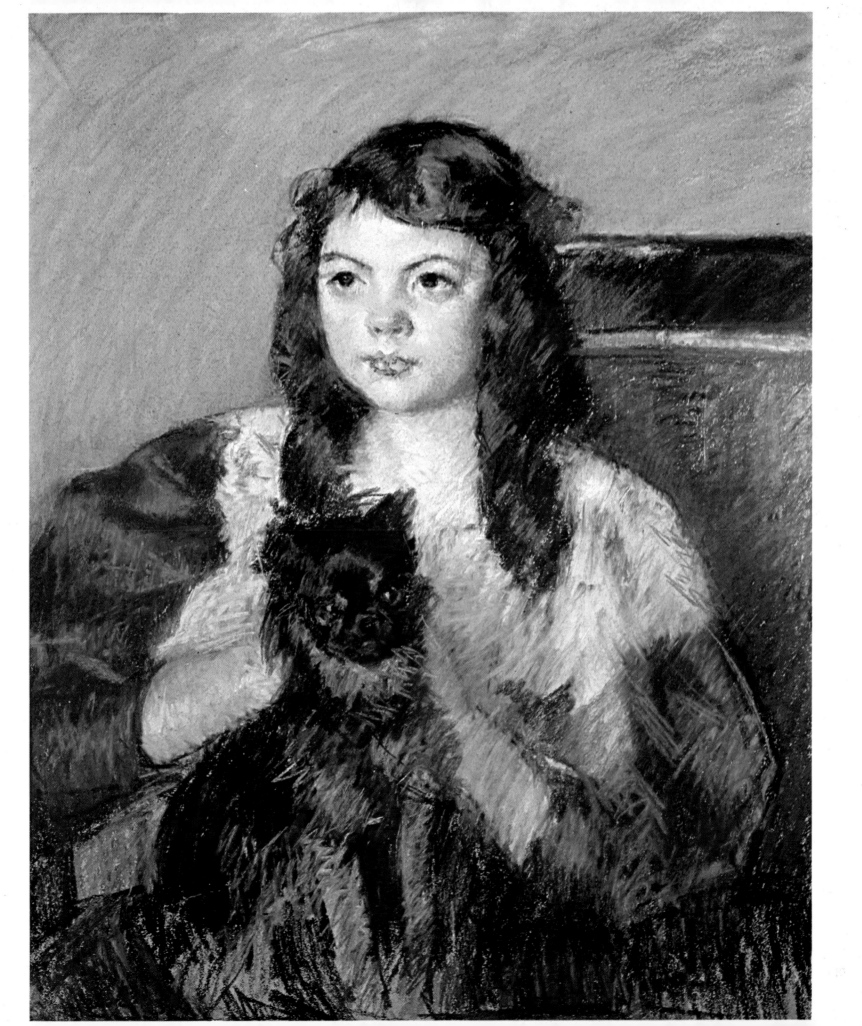

Plate 30
ANTOINETTE AT HER DRESSING TABLE
1909
Oil on canvas, 36½″ x 28½″ (92.8 x 72.4 cm.)
Collection Mrs. Samuel E. Johnson, Chicago, Illinois

The organization of this painting depends on the repetition of round shapes. The changing scale of these circles, from smaller to larger, leads the eye of the viewer back into the composition: from the hand mirror, to the woman's head, to the frame of the dressing table's mirror. This rhythm is repeated by the curves of the woman's arms, the billowing sleeve of her dressing gown, and the arm of the chair. The dark braiding on the lapel of her gown provides the one emphatic, contrasting angle in the composition.

Cassatt's use of a limited color scheme beautifully unifies this painting. The rose dressing gown and chair and the reddish browns of the wood furniture provide a subtle contrast to the moss green dress. Here color, rather than line, is used to compartmentalize the forms. The golden yellow outline of the hand mirror projects this important compositional form toward the viewer. The broad brushstrokes in this painting are similar to the free and agitated use of chalk in Cassatt's pastels of this period.

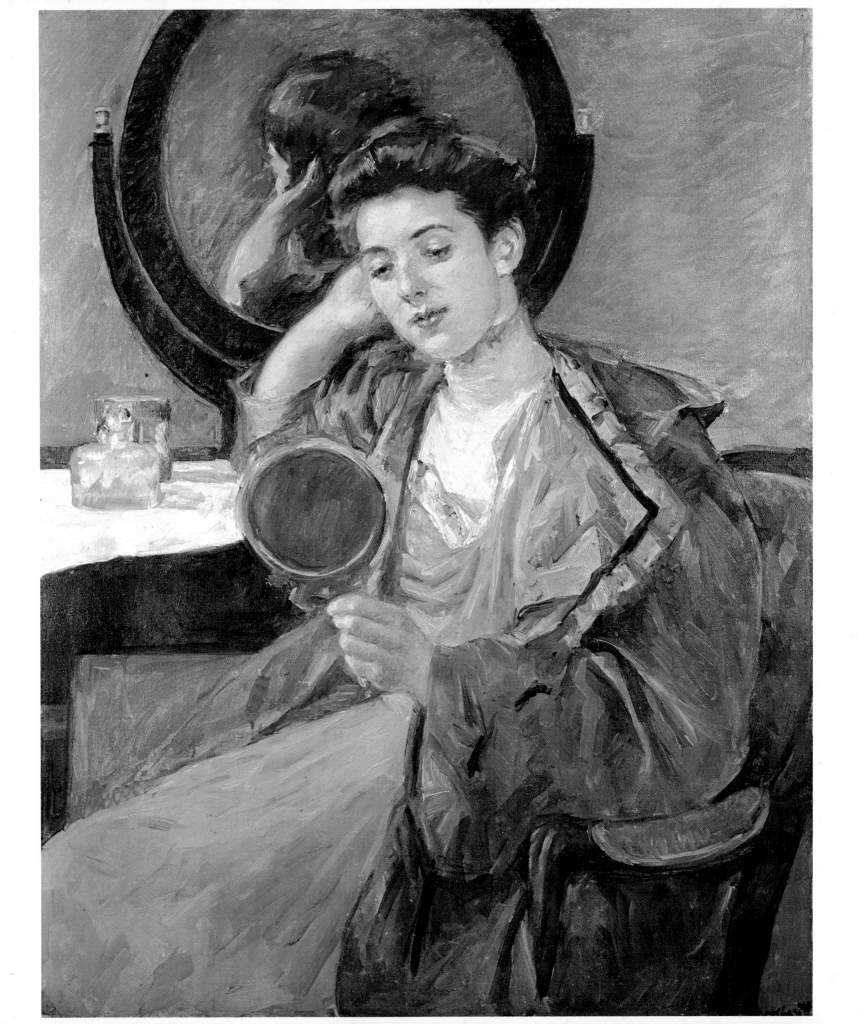

Plate 31
THE CROCHET LESSON
1913
Pastel on paper, 30⅛″ x 25½″ (76.5 x 64.8 cm.)
Collection Melvin and Estelle Gelman, Washington, D.C.

In December 1910 Cassatt joined her brother, Gardner, and his family on a trip to the Near East. The two months spent in Egypt exhausted the artist, both physically and creatively. Her brother had become seriously ill on the trip also and died in Paris in early 1911. The loss of the last member of her immediate family caused Cassatt to suffer a complete nervous and physical breakdown. As a result, she was forced to give up her work for almost two years.

This pastel dates from the short period after her recovery when Cassatt was able to work once more. By 1914 cataracts had developed on both her eyes and she was forced to give up her art again, this time permanently. The trends seen in her work before 1910 are accelerated in these final pastels which became her exclusive medium. While her palette remained limited, the colors are ever brighter, at times even harsh and strident. In this picture, all details have been eliminated. The essential forms and gestures of the two figures dominate the composition. The pastel has been applied in quick, slashing strokes crushed into the paper.

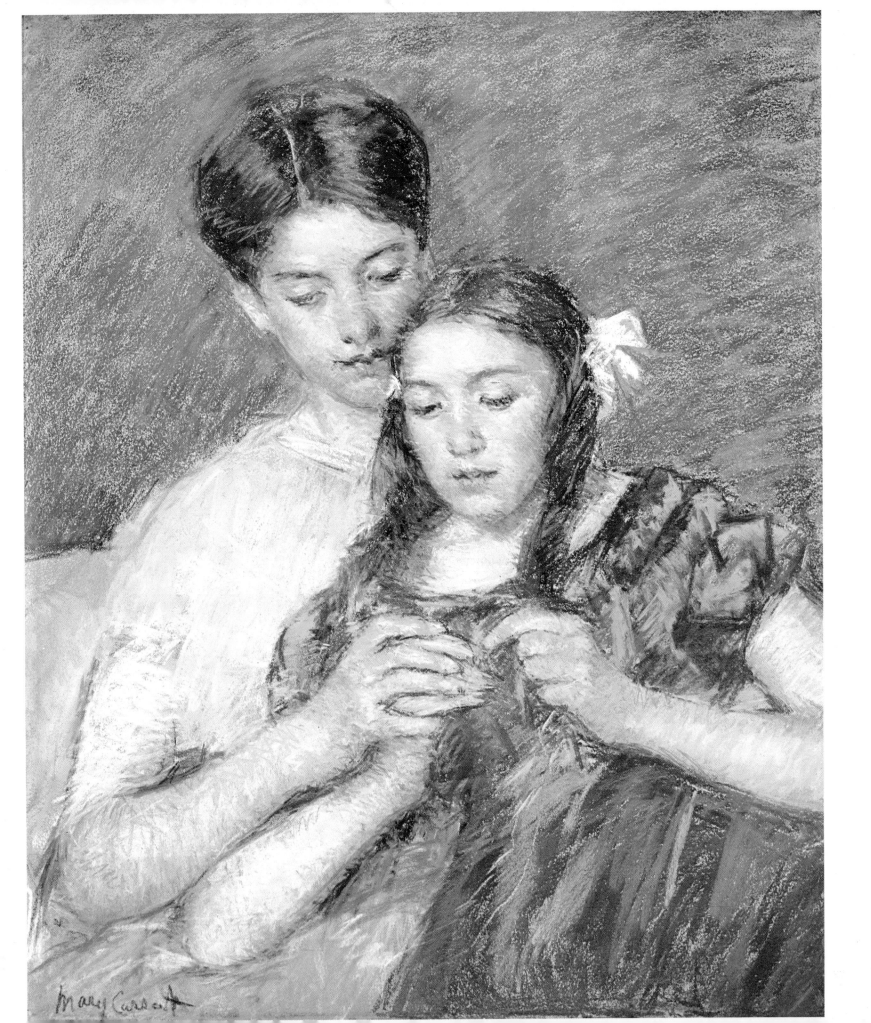

Plate 32
MOTHER, YOUNG DAUGHTER, AND SON
1913
Pastel on paper, 43" x 33½" (109.3 x 85.1 cm.)
Rochester Memorial Art Gallery, Rochester, New York

Mary Cassatt's final pastels were admired by her friends and associates. She was particularly pleased when both Louisine Havemeyer and James Stillman acquired examples for their collections. Cassatt herself also seemed satisfied with these works and wrote to Mrs. Havemeyer (December 4, 1913), "I brought seven pastels to town, four were large, a nude boy and his Mother. They were in many respects the best I have done, more freely handled and more brilliant in color. . . . The Durand-Ruels were most anxious to buy and other dealers too."

This may be the picture referred to in the letter. The largest and most successful of her last pastels, it was one of the works acquired by Mrs. Havemeyer, who felt that such late pictures displayed, "strong drawing, great freedom of technique and a supreme mastery of color." Certainly the fine design of this work, the vivid colors, and the nervous application of chalk makes it more interesting and original than many of her pretty, formula pictures of the early 1900's. Perhaps if blindness had not stopped her development, Cassatt might have been able to achieve the freedom and expressionistic excitement found in Degas' last, tortured pastels.

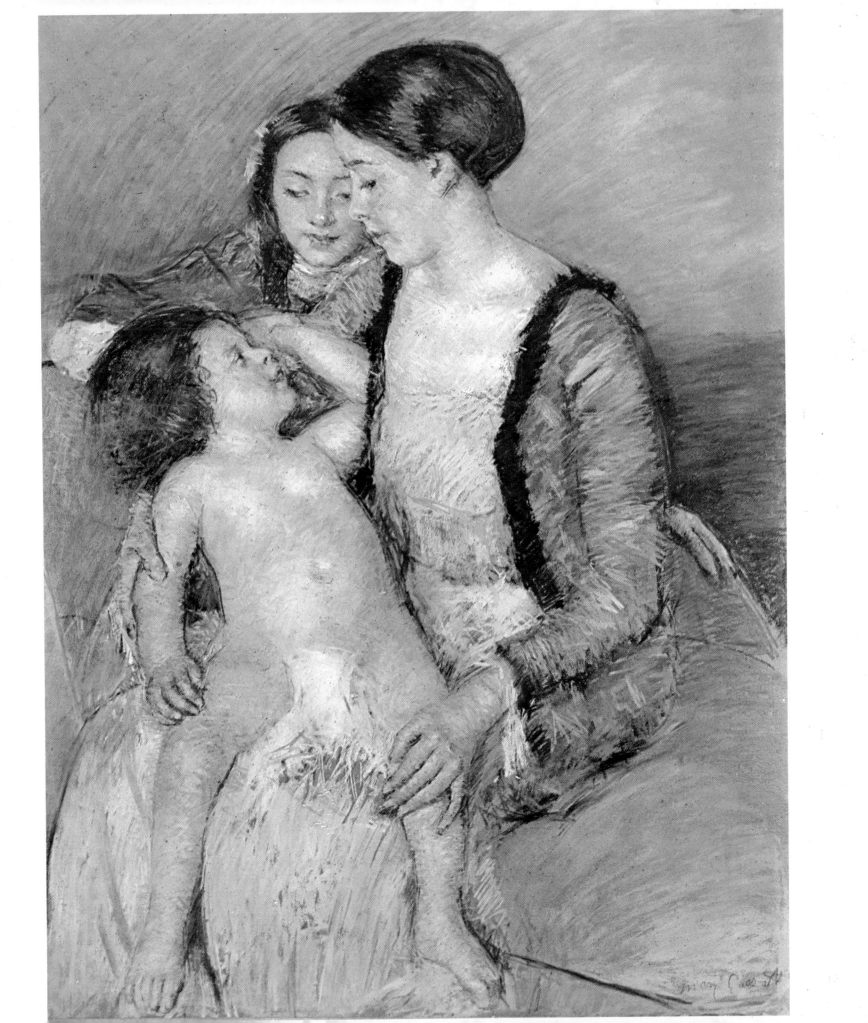

Edited by Diane Casella Hines
Designed by James Craig and Robert Fillie
Composed in 10 point Medallion by Publishers Graphics, Inc.
Printed and bound in Japan by Toppan Printing Company, Ltd.